Pre-Columbian Mexican Miniatures

PRAEGER PUBLISHERS    *New York · Washington*

Anni Albers

# PRE-COLUMBIAN MEXICAN MINIATURES

The Josef and Anni Albers Collection

Foreword by Ignacio Bernal

Introductory Text by Michael D. Coe

Photographs by John T. Hill

BOOKS THAT MATTER
Published in the United States of America in 1970
by Praeger Publishers, Inc.
111 Fourth Avenue, New York, N.Y. 10003
*All rights reserved*
Library of Congress Catalog Card Number: 70–99925
Printed in Great Britain

*Design and sequence by Norman Ives*

# Acknowledgments

*I wish to thank Michael D. Coe for writing the introductory text and for compiling the map with the archaeological zones and specific places, also for identifying and cataloguing the objects presented here and giving his stamp of authority through his wide knowledge as an archaeologist.*

*John T. Hill I thank for the sensitive photographs that he took with great care, skillfully recording the delicate essence of each piece.*

*To Ignacio Bernal go my thanks for his kind and generous comments in the Foreword, for which he found time despite his work as an author and his official duties as director of the National Institute of Anthropology and History in Mexico.*

*To Norman Ives I am grateful for heightening the content of this book by giving it a form that demonstrates his admiration and love for the art shown here.*

*To Horace Winchell I am indebted for taking the trouble to identify, as a geologist and leading expert on the mineralogy of Mexico, the small stone images included in this book.*

*To Josef Albers, my husband, I owe here, as co-collector, my special gratitude.*

**A.A.**

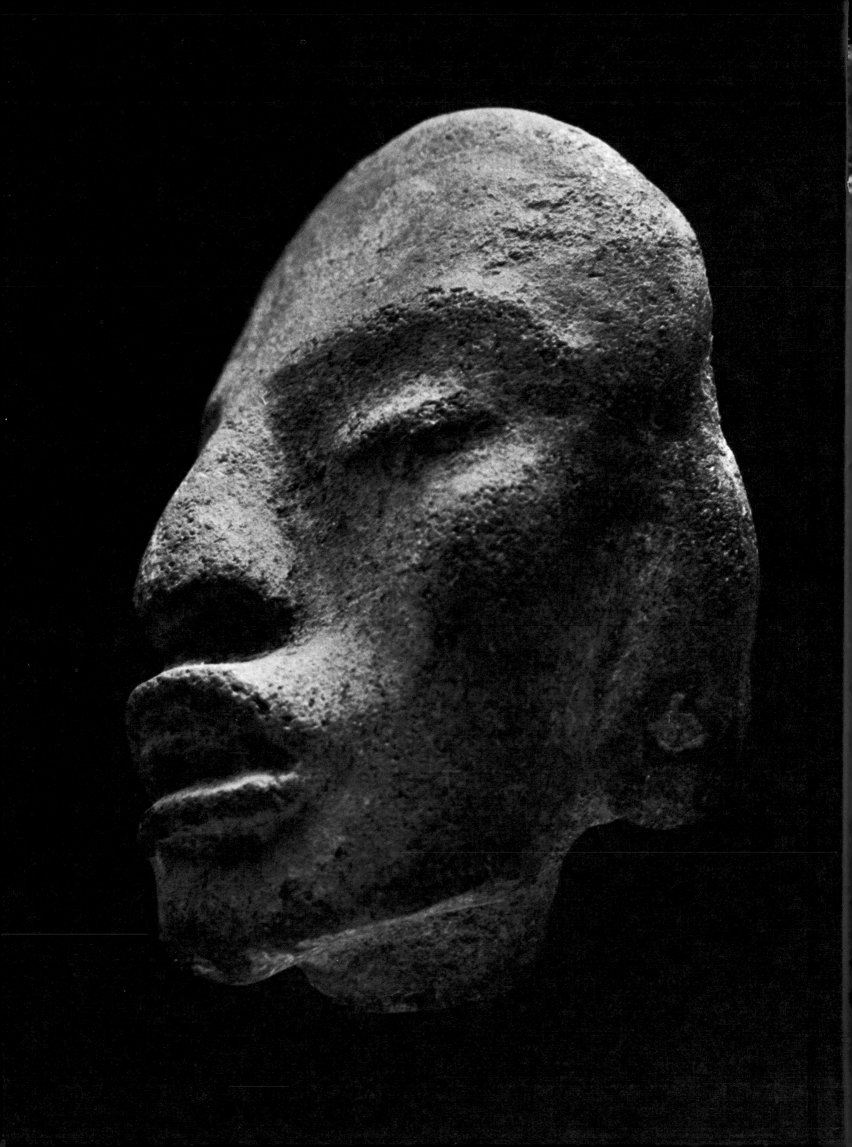

We experience art today to a large degree through photographic reproductions that bring us objects of the present and, importantly, those of remote periods and distant places. Mostly they are shown reduced from their real size—in some cases from a monumental size. In this presentation, the reverse is true. By the simple act of photographic enlarging, small-size images, devotedly formed in the modest material of clay—each worthy of being considered an object of art but, because of its smallness, easily by-passed— are brought to dimensions more easily seen. It thus permits them to compete regardless of actual dimensions. It becomes obvious, then, that greatness is not a matter of volume, that the monumental can be imbedded in the minute.

Though chosen from a collection that includes also larger pieces, those shown here are under 12.5 centimeters, that is, 5 inches, which is the size of only one piece (by far the tallest), included here because it is unique. The whole collection can be held in two hands, and its weight is less than seven pounds. It is truly a lesson in economy of artistic articulation, as all art is an act of condensation.

Not only had my husband and I marveled at the great pieces of pre-Conquest art in the museums and collections of Mexico, but I remember vividly having seen and admired examples of it, large and small, in a Berlin museum many years earlier. To see this art now in its own setting kindled anew the sense of its greatness.

During our many trips to Mexico—fourteen in all, some of three months' duration and dating back as far as 1936—we had gathered here and there material covering some of the diverse early cultures of this ancient country. Our first small pieces came to us on our visits to prehistoric sites

*from little boys offering them to us through the car window, just as turkeys and goats were also held up for sale. As we examined the fragments of pottery, which included subtly formed heads and, alas, usually broken figurines, we could not believe that here in our hands were century-old pre-Columbian pieces found by the peasants when plowing their fields. We showed our little treasures to the late George Valliant, the authority on Mexican archaeology, who was excavating at the time on the outskirts of Mexico City, and he confirmed their authenticity. Yes, here was a country whose earth still yielded such art.*

*As our interest in and our love for the art of pre-Conquest Mexico grew, we ventured into regions not yet then included in the regular tourist itinerary. I remember a woman in a remote part of the country holding out in her hand a delicately fashioned little clay head she had found, and, when asked about it, she said: "Es natural," that it belonged to the soil she knew.*

*Most of the pieces shown here bring back recollections of places and incidents. Our special interest led us to regions that heightened our sense of adventure and discovery. We went along high cactus fences in village streets silent and empty, but whenever we turned around and looked back, faces would quickly withdraw and hide. We were obviously the sensation of the day. We sat in fields, sandwiches in hand, and wherever we looked, ancient pottery shards protruded.*

*We never found anything startling, but we were aware of layer upon layer of former civilization under the ground, waiting for excavation. When we flew over the countryside, it was easy to spot again and again mounds not yet touched by archaeologists.*

*At the time of our early visits, pre-Conquest art had not yet found acceptance as an art, and we felt the excitement of discovery. Only such Mexican artists as Diego Rivera and Miguel Covarrubias recognized the greatness of the indigenous art of their native land, while the social élite appreciated almost exclusively the art of the Western European tradition.*

*Both Rivera and Covarrubias built vast collections. We were among the privileged few "gringos" to see, many years ago, the Rivera collection at his house in San Angel (built by O'Gorman and reminiscent of Le Corbusier's designs) and later in his house in Coyoacán (in traditional Mexican colonial style). We felt that Rivera had an oversized appetite for all that came to light and was brought to him by the natives from many parts of the country. The pieces in his collection varied from unsurpassed, rare, and precious stone masks and clay figurines of great power, to poorly broken pottery bits that must, however, have carried a meaning for him in his speculations on archaeological history. Rivera built a museum for his collection, which he donated to the nation. At the time he showed us Anahuacalli, then only a half-finished building of rough lava-stone from the surrounding Pedregal, the lava beds at the outskirts of Mexico City left from a volcanic eruption some 2,000 years ago, it was an impressive gesture, for no worthy setting existed yet for the ancient arts of the country.*

*Unfortunately, we never met Covarrubias or saw his collection as a whole. We saw sections of it in the old anthropology museum and had a chance to admire what his highly discerning eye had brought together.*

The pieces are now no longer shown as a group but are intermingled with others in the vast exhibitions at the imposing new Museum of Anthropology in Mexico City. Rivera's museum suffers by comparison, not only for its too personal choice of objects but also by the unparalleled quality and superior presentation of the pieces in the Museum of Anthropology, selected and displayed under the supervision of its director, Ignacio Bernal. This museum attests to the recognition, at last, of the greatness of Mexico's sculptural arts.

Pre-Columbian art no longer needs pioneering collectors to acknowledge its importance, not merely for its highly developed sculptural quality but also for its remarkable diversity. There is no one style dominating all regions and epochs. In fact, new excavations and new dating methods alter the archaeological picture continually and expand its horizon. A new terminology is also evolving as styles emerge, each more clearly defined in its own right. For us, as amateurs in the true sense of the word and mainly visually oriented, the old anthropology museum housed in an ancient palacio was the main source of information. Here, the pieces were simply placed side by side in old-fashioned glass cases, often crowded together with no attempt at showing them to any advantage. They were regarded merely as specimens. But they afforded us a chance to compare, and, by comparison, to distinguish and to learn, however sketchily. Since labels were sometimes missing and sometimes puzzling to us, it was a challenge to our observation. Now, of course, the new museum helps the observer in a more direct way. By being shown its choicest objects, one no longer has to scramble visually through fine and poor pieces before coming up at last with newly gained insight. However, in this respect, the old museum did give us the satisfaction of independent exploration.

Not only is pre-Columbian art now recognized as art, and as great art, but it has also become fashionable and prestigious to collect it. As with all fashions and fads, there is now an overlay of impermanence that clouds the timelessness of the true art value, although a stimulus has been given to new excavations, legitimate and illicit. What once had little value has become high-priced and in great demand. To guard its heritage, the Mexican government now prohibits the exportation of its art treasures.

Tlatilco, now a brick factory, is the place where the workers, in the course of their daily routine, brought to light many of the most significant and oldest figurines of the region. It was the great treasure-hunting ground of Rivera and Covarrubias and, later, of others, so we were told. The people there lived in appalling squalor. The children would come up to us with their latest mud-covered findings. Only at home, after we had washed the pieces, would we be sure that what had looked vaguely promising was as beautiful as we had hoped it would be. Important pieces, it seemed, would be secretly saved for the big collectors. For some years now, the area has been guarded by the government, and professionally supervised excavations have been carried out.

I remember having bought, years back, in a curio shop in Mexico City, a small, mold-made clay figurine representing Tonantzin, an Aztec deity. I did not know whether there were any regulations then for taking it out of the country, so I showed the piece to the museum authorities. "Take it, take it" they said, "we have many of them. Yours is a very nice one."

*Usually, with small change in our pockets we would go to sites shown on our archaeological map (which, interestingly, one could get at the gasoline-station offices). We did not venture into areas inaccessible by car, but we visited pyramids, enormous ones and small ones, somewhat out of the way, that left us in awe of the great concepts of their architecture. The smaller places were rarely visited by tourists; the coming of a tourist was truly an event that soon brought women and children to the site to shyly observe us and then to open their baskets or pull from their pockets little clay images, some shown enlarged here. Sometimes it came to typical bargaining sessions, the expected game of the market place: "Ten pesos, no five pesos, two." Once, my husband, his Spanish even more limited than my own and therefore not quite following these ups and downs, broke in and, turning to me, said: "Why don't you offer thirty pesos and that is that?"—a price way beyond what had been considered at all. Whereupon, the young fellow turned to me and said: "See, lady, the señor has a real understanding of art!" He was right, of course.*

*At another time, at the great pyramids of Teotihuacán, which is a tourist attraction, genuine little clay pieces would be spread out on the ground next to ones that were obviously newly made. As we were cautiously selecting the fine pieces from poorly formed or badly broken ones, I heard a lady tourist say: "No thank you, I only buy what I really can use!"*

*Yes, art is useless, in a sense. But it has a restorative power that we need again and again. It assures us of a timeless meaning across epochs and regions, despite the absurdities proclaimed these days in art circles.*

*Perhaps it was this timeless quality in pre-Columbian art that first spoke to us, regardless of our ignorance of the special significance it must have had to a contemporary community. We were struck by the astounding variety of its articulation, by the numerous distinct cultures and resultant differing formulations. It made clear to us anew that a humble material, such as clay, can be turned into images equal to those made of precious material. It also taught us that a society need not be prosperous to produce great art. In fact, one wonders if the reverse is not true. And today, when large size in art is carried to an absurdity, the smallness found here seems to be a special virtue, when contrasted with the arrogance of exaggerated scale.*

*Since it was the small relics that first engaged our interest and our curiosity, and that enchanted us, this book is dedicated to them. But, more importantly, its purpose is also to show convincingly that neither impressive size nor rare material are essential to the manifestation of art.*

*Above all, the material presented here is intended as a gesture of our thanks to the anonymous makers of the small-great objects that have given my husband and me such delight.*

ANNI ALBERS
*November, 1969*

# Foreword

*It has been claimed that the Pre-Classic figurines of Mexico constituted a religion for those who had not yet invented their gods, and that they represented fertility rites—invoking not only human fertility but also that of the earth, which the early agriculturalist watered with the sweat of his toil. Whether or not this is true, for us they represent primitive beauty, the earliest evidence that the people of these regions showed an interest in their own image; with inexperienced hands—though highly dexterous and sensitive—they modeled actual or ideal features of the people they saw around them. The collection (which includes later figurines as well) presented by Mrs. Albers is small but it has been chosen with great love and talent, and brings to our world (more complex but no more sophisticated than a Tlatilco figurine) the delicate fragrance or the raucous vitality of those women of ancient times. With apparent simplicity, their anonymous creators began— as occurred in Egypt and China and all sites where civilization later arose— on the same path that is followed by great arts of more mature periods.*

IGNACIO BERNAL

# Figurines

Few objects from antiquity appeal as immediately to the contemporary beholder as do human figurines—miniature representations in clay, wood, stone, and bone of the people who were the bearers of long-extinct cultures. Opposed to the much larger, more hieratic works of public art, which were designed to impress upon their contemporaries the awesome power of politicians and gods, these smaller creations (very often masterpieces in their own right) apparently had a more private, more humble meaning to our ancestors. The meaning or purpose of the figurines changed from culture to culture, but, in general, they seem either to have functioned in household rather than public rituals or to have been included in the grave as funerary offerings.

As far as we know, the oldest figurines in the world may have been made as long ago as 29,000 years, in the Gravettian cultures that were scattered from western Europe to Siberia during the Upper Paleolithic period. These are the so-called Venuses, fashioned of mammoth ivory or, occasionally, of clay, that depict gloriously fat women, usually pregnant, with pendulous breasts and monstrously inflated buttocks. From the start, the female form was the preferred subject of the anonymous artists producing figurine art in all quarters of the globe.

Why was this so? In his book *The White Goddess*, Robert Graves makes much of the artist's preference. His theory is that the female figurines of Paleolithic and Neolithic Europe and the Near East represent a cult that worshipped a mother goddess, symbol of the world as it was when societies were supposed to have been ruled by matriarchies—a corollary of the ritual importance of women and female fertility to primitive

hunters and farmers. This theory, harking back to the "Mutterrecht" of Victorian anthropologists, is hopelessly out of date and most probably wrong; according to the findings of modern anthropology, it is likely that many social systems flourished in the Old and New Stone Ages, with matriarchy probably the rarest. It is true, however, that wherever these objects were fashioned, the dominant figurines were those of women— sometimes pregnant but most often young and beautiful. One has only to recall the wonderful Cycladic figurines of marble, the delicate figures of Tanagra, the amusing and naïve pottery ladies of Neolithic India, the female dancers and polo players of T'ang China to see that this is so. On the other hand, recognizable depictions of gods are correspondingly rare in works of art on this scale.

Another striking feature of figurine art is the frequency with which the activities of everyday life appear; this may be peasant life, life "belowstairs" in a palace, or court life (as in the Chinese tomb figures), but a perfectly mundane life nonetheless. Quite clearly, the good and desirable things on this earth are being depicted: beautiful and fertile women, servants preparing food, court dancers and musicians, cattle to eat and to work the fields, men to herd them, and so forth.

Now, where are such figurines found? Figurines that have come to us complete or nearly complete have been taken almost always from graves or tombs, either by archaeologists or by professional hunters of pots. This is true of such diverse cultures as Greek Tanagra, Egypt, T'ang China, and the Hopewell culture of the United States, and also, as we shall see, of several of the pre-Columbian cultures of Mexico. It is easy to see the idea behind this: to send off with the honored dead all the good things that he would need in the life after death, not only food and drink but also what had delighted his eye when he was alive. Some years ago, I watched with fascination a Chinese family in a temple on the island of Taiwan following this logic. They were on a periodic visit to the temple's holy incinerator, and into it they were feeding make-believe paper money, paper servants, and even paper motor cars, which their deceased relative required in paradise. This was a far cry from the T'ang Dynasty, when magnificent pottery groups of complete palace retinues accompanied the dead kings and nobles to their graves, but the idea was surely the same.

Nonetheless, there are times and places in which figurines appear as fragmentary and casually discarded items in the trash of ancient settlements. There are several possible explanations for this. After all, dolls as objects to be manipulated by the young seem to be a psychologically important necessity to most peoples of the world, and it is not unlikely that archaeologists have read esoteric meanings into figurines that were little more than playthings. For instance, jointed figurines whose limbs or heads can be moved about are not uncommon in early settlements in both hemispheres. Most curious are the animal figurines of ancient Mexico that were fitted with wheels so that they could be dragged about by children, the only known application of the wheel in the native New World.

Household and ex-voto figurines might also account for some of the objects that occur in early rubbish. The Romans are known to have used simple figurines in their cult of the Lares and Penates, which was

concerned with honoring the lineage ancestors and the hearth. As for ex-votos, the offering up to the gods of a surrogate limb or other afflicted part of the body, shown in miniature, continues to this day in the Christian churches of Mediterranean countries.

Thus, we shall see that some of the Mexican figurines presented in this book were funerary in function, while others were probably akin to the ancestral figures of household cults; and I suspect that some in collections not represented here may even have been ex-votos. Although the strangeness of the Mexican civilizations is often stressed, the more one knows about them, the more one can agree with the writer of Ecclesiastes: "The thing that hath been, it is that which shall be; and that which is done is that which shall be done: and there is no new thing under the sun."

## Ancient Mexico

It would not be out of place to summarize briefly what we know of the cultural milieu that produced the miniature art pictured in this book. In this day of the large and lavish art book, many have been tempted to produce the so-called "museum without walls," tearing objects from the contexts in which they were created and scattering them across pages at random; or, even worse, in the urge to make a point, juxtaposing superficially similar things that are at heart quite different, for example, a Picasso portrait of the 1930's with a Pre-Classic, multiple-featured figurine head from Tlatilco in Mexico. To make sense of such a product is like trying to understand a sentence every word of which is in a different language.

While all of the figurines and other miniatures shown here originated in Mexico, "Mexico" is basically a political term encompassing the modern republic of that name. A more fitting term for what we are talking about is Mesoamerica, meaning the portions of Mexico and adjacent Central America that were civilized in pre-Columbian times and that held many specific cultural items in common, such as a very complex, permutating calendar. Among the greatest civilizations of Mesoamerica in relatively late times was that of the Aztec, whose empire covered much of central and southern Mexico, down to the isthmus of Tehuantepec. Beyond, to the southeast, was the domain of the Maya, who were settled in the Yucatan Peninsula, Guatemala, British Honduras, El Salvador, and the western part of "Spanish" Honduras. But other high cultures of considerable importance were created by the Totonac of Veracruz, and by the Zapotec and Mixtec of Oaxaca.

All of these peoples were conquered by the Spaniards from 1519 on. Only in the last century have we learned of other, much more ancient civilizations, of which only the most meagre traditions remained among later groups. The most spectacular is that of the Maya during the Classic period, which is dated from A.D. 300 to 900, on the basis of the correlation of their calendar with ours. These were the most advanced of all the peoples of the New World, far more so than their descendants of the sixteenth century. Another discovery has been that of the great Teotihuacán civilization, a contemporary of the early Maya, which was probably the mightiest power ever to exist in Mesoamerica. In recent years, in a startling

development, archaeologists uncovered the remains of an even earlier people, the Olmec, who flourished in the Pre-Classic period. The use of radiocarbon dating procedures has helped to establish the considerable antiquity of this major civilization.

In short, we have an archaeological scheme for Mesoamerica organized into broad periods; the dates for each period and culture may be based on ethnohistoric sources (from documents written down after the Spanish Conquest), on native calendar systems such as that of the Maya, on radiocarbon determinations, on stratigraphy and trade pieces, or on various combinations of all of these. These broad periods are:

*Early Hunters*—11,000(?) B.C. to 7000 B.C. Toward the end of the Pleistocene or Ice Age, Mexico was first occupied by very small bands of Indians, who lived by hunting such animals as mammoths and mastodons and by gathering of wild-plant foods. Shortly before 7000 B.C., the climate became much as it is today.

*Archaic*—7000 B.C. to 1500 B.C. In central and southern Mexico, some groups of Indians began cultivation of the great New World food plants—maize, beans, and squashes. By the close of the period, people were living in rudimentary villages, pottery-making and weaving had begun, and the foundations had been laid for more complex life.

*Pre-Classic* or *Formative*—1500 B.C. to A.D. 200. Until recently, this period, to which the majority of the figurines in this book can be ascribed, was considered to be a time when simple farming villages spread all over Mesoamerica, and little more; however, we now know that several important civilizations are this old, especially the one called Olmec.

*Classic*—A.D. 300 to 900. This marks the apogee of Mesoamerican civilization, a kind of Golden Age, during which flourished the great cultures of Teotihuacán in central Mexico and the Maya to the southeast of them. There were large centers and even cities throughout Mesoamerica, and native calendrical science reached its height.

*Post-Classic*—A.D. 900 to 1521. There is some evidence that militarism, expressed in the rise of warrior orders and in imperial conquests, was stressed more at this time, following the downfall of the Classic civilizations, than previously. In central Mexico, first the Toltec and then the Aztec established their power over very wide areas.

This, then, is the picture of the overall development of Mesoamerican prehistory as we now understand it. It is sure to be changed in some details: for instance, it is by no means certain that there was any great socio-political difference between the Classic and Post-Classic periods, since the large body of documents we have describing life in the Post-Classic may make it merely *appear* different from the Classic, which we know only from archaeology.

## Tepictóton

The Aztec, on whom we have an enormous amount of information, coming to us mainly from the early Franciscan fathers, called figurines *tepictóton*, meaning "little modeled ones." While such figurines must have been made by the millions in ancient Mesoamerica (and we have a great many of

Aztec workmanship), there are curiously few references to the *tepictóton* in our sources. The most interesting and complete reference is given in the great encyclopedia of Aztec life compiled by Father Sahagún. It describes figurines being fashioned from dough in honor of mountain gods accompanying Tláloc, the Rain God, and Chalchiuhtlícue, his consort:

> *If someone makes* tepictóton
> *after having promised it,*
> *he makes the images of the mountains*
> *of all those that he wants,*
> *he makes his* tepictóton.
> *It is as though he would reproduce the beings that smoke,*
> *he forms them in the shape of Tláloc.*
> *He makes them with amaranth dough,*
> *bedaubed,*
> *with their paper headdresses,*
> *with paper ornaments on the neck, with quetzal-feather tassels,*
> *With their paper garments,*
> *with their traveler's staff in one hand.*
> *Likewise the god of the white mountain,*
> *his finery:*
> *the clothes of both are painted with rubber.*
> . . .
> *In this manner they placed them:*
> *they put them on the ground in a row,*
> *face to face with a fifth one,*
> *which they called Quetzalcóatl,*
> *the finery of this one:*
> *made in the style of the Wind God. . . .*
> *Thus it was that they adorned them,*
> *because they were called* Tlaloque [*attendants of Tláloc*],
> *and it was believed that they caused the rain.*

Thus, at least, we know that the Aztec made perishable figurines in the shape of certain gods.

Father Torquemada, another excellent source, supplies confirmation that "they made little images, some in honor of the gods and others in memory of some dead persons. . . . When persons died by drowning, instead of cremating them (as was their custom) they interred them, making some images which represented them and which they put on the altars of the idols."

But this hardly explains why there should be such an incredible profusion of figurines throughout Mesoamerica, nor why depictions of deities should be so rare. There is, moreover, a hint in our sources that some little images represented real people, who had recently died; certainly, in Classic times, some figurines were portraits. As we survey the earlier cultures represented in this book, we shall see that most reflect what we have already talked about, the good things of contemporary life.

*The Valley of Mexico in Pre-Classic times*

Few regions of the world have produced figurines in such quantity as the Valley of Mexico, a high, internally drained basin that was, in the Post-Classic period, the capital of the Aztec Empire and that is now the location of Mexico City. Far earlier, around the lake that once filled the basin, there were a number of large and prosperous Pre-Classic villages. The greatest of these was Tlatilco, now the site of enormous brickyards on the north-western edge of Mexico City. The *tepictóton* of Tlatilco have been known to discerning collectors since the early 1940's, when the brickyard workers began to encounter incredibly rich graves in their excavations. Never before had such a sophisticated and rich Pre-Classic settlement been known.

Tlatilco has wrongly been thought of as a cemetery, on the basis of the hundreds upon hundreds of graves that have been found there. More likely, it was a rich settlement consisting of thatch-roofed houses with earthern floors; here, as elsewhere in Mesoamerica, the preferred place of burial was directly below the house floor, the whole concept of a cemetery apart being foreign to native tradition. But what graves! They were literally stuffed with figurines, pots of incredible sophistication, and such imported items as red hematite and asphalt lumps.

One of the real problems of Tlatilco has been its dating. Recent information suggests that the settlement lasted for much of the Pre-Classic period, from perhaps 1200 B.C. to 300 B.C. Thus, there is a considerable variety of styles in its pottery and figurines. The oldest figurines are found near Tlatilco but not necessarily in the site itself, but since many are complete they must have been funerary offerings. These are the so-called Type M, or Cañitas, figurines, which are crude but lively; with bodies made of two rolls of clay worked together, and often with circles of dots around the eyes. They are strongly reminiscent in construction of figurines of the Valdivia culture on the coast of Ecuador, which date back to about 2800 B.C. and from which our Cañitas type may be derived.

A salient feature of Tlatilco is that it has produced figurines in Olmec style. The Olmec civilization of the Gulf Coast of Mexico has now been demonstrated, at the great ceremonial center of San Lorenzo, to have been as old as 1200 B.C., and, at sites like La Venta, to have lasted until about 400 B.C. In its hot, wet homeland on the coast, it features basalt sculptures of great style as well as smaller jade figures of incredible delicacy and sophistication. The hallmark of the Olmec style is the were-jaguar, a mythical creature that combines the features of a snarling jaguar with those of a crying baby. Wherever it is found—and the Olmec presence is known elsewhere in Mesoamerica—are also found figurines with the characteristically Olmec drooping mouths and puffy chins and faces, the greatest of which are the large, hollow whiteware figurines from Tlatilco and from Las Bocas, in Puebla. And wherever Olmec is present, the people accompanied their dead with *tepictóton*.

Shortly after the intrusion of Olmec people or influence into the Tlatilco area, around 1100 B.C., the figurine-making art reached its height. I am speaking here of the magnificent D¹ and D⁴ types which are found by the handful in some burials. The sophistication and humor displayed by these tiny, hand-modeled creations has to be seen to be

appreciated. Many show young ladies with hugely plump thighs, wearing fringed skirts; or dancers (some of whom are masked) with rattles on their legs; or males attired in the garb appropriate to the sacred rubber-ball game; or weird figures of witch doctors and deformed persons. Gods again are rare, for here we are faced with an art of the here and now designed for future comforts in the after-life. An adequate study of Type D figurines at Tlatilco would surely show the work of individual hands or perhaps traditions of family *tepictóton*-makers. More strongly divergent styles, such as Type K with its goggle-like eyes, are known to be contemporary with Type D, for they are found in the same graves; and we believe that they were perhaps traded from other regions.

After 900 B.C., Olmec and allied traditions began to weaken at Tlatilco and other parts of central Mexico (such as Puebla and Morelos), and were replaced by figurine styles of the Middle Pre-Classic at such sites as Zacatenco and El Arbolillo on the northern side of the Valley of Mexico. The newer styles, dryly labeled as Types C and B, were never any match for what had flourished in the previous centuries. Toward the end of the Pre-Classic, Teotihuacán began making its influence felt, and we enter another world.

### Chupícuaro

Almost as well known and beloved to collectors as the figurines of Tlatilco are the *tepictóton* of Chupícuaro, a Late Pre-Classic village on the upper Río Lerma in the state of Guanajuato, not far from the Michoacán border. Now inundated by a man-made lake, its burials—probably to be dated between 300 B.C. and the time of Christ—were accompanied by magnificent polychrome bowls and large numbers of amusing figurines. In place of the variety of Tlatilco, we have here a very restricted number of representations, almost like gingerbread men, of nude men and women (the latter in the majority); the bodies are usually extremely flat, with features indicated by fillets of clay and by punching, as well as by painting in red, white, black, and ochre. Again, the subjects are from "real life," the nude "pretty ladies" with slanting eyes being particularly attractive. And, in very large collections, it would be most interesting to study types, subtypes, and even the creations of individual hands; for, in spite of their apparent simplicity, Chupícuaro figurines are among the most sophisticated art objects from ancient Mexico.

### Michoacán and Guerrero

Actually, there is a host of interrelated figurine styles during the Late Pre-Classic, extending from the Valley of Mexico (in which Chupícuaro figurines have been found) all the way to the Pacific coast. The state of Michoacán, homeland of the Tarascan people in later times, was the locale for a number of these styles; in the east of the state, figurines look like Chupícuaro, while in the west they tend toward Colima and Nayarit types.

Probably nowhere else in Mesoamerica does the human figure become more abstract than in some of these Late Pre-Classic *tepictóton*, with eyes, ear ornaments, and so forth becoming almost disassociated from the persons wearing them. As one moves toward the Pacific coast,

particularly in Guerrero, figurines again become more "realistic," good examples of this trend being the extraordinarily effective ladies known from the region around Zihuatenejo. Unfortunately, the entire region of western Mexico—Guerrero, Nayarit, Jalisco, and Colima—is little known archaeologically, so that we have little knowledge of the context in which either the small figurines or the more spectacular pottery tomb groups are found.

## Veracruz

Olmec influence, curiously enough, never did spread very far north along the coast from its "heartland" in southern Veracruz and Tabasco, just as it never seemed to have moved directly into the Maya lowlands of Yucatan and the Petén; apparently, the Olmec lords were far more interested in the exotic lands of the Mexican *altiplano*, where they could obtain luxuries not available in the low country. A series of Pre-Classic villages that were outside the Olmec orbit has been discovered near the modern port of Tampico along the Pánuco River in far northern Veracruz. They show an evolution from Early Pre-Classic into Proto-Classic types, with the height of the figurine art occurring in the Pánuco III culture.

But of more aesthetic interest is the development of clay sculpture that was taking place farther south, in the Remojadas region of central Veracruz, toward the very end of the Pre-Classic. Here, where oil seeps were common and float material collected easily on beaches, glossy black bitumen (*chapopote*) was lavishly used in figurine decoration. All through the evolution of Remojadas figurine art, which presumably lasted until A.D. 900 or later, there is an extraordinary interest in genre scenes; particularly famous are the figures of inanely smiling boys and girls, which began as a tradition in the early Remojadas culture.

## Teotihuacán

About the beginning of the Christian era—corresponding to the Late Pre-Classic of Mesoamerica—a mighty city began to take form in a side valley on the northeast edge of the Valley of Mexico. This was Teotihuacán, destined to become, during the subsequent Early Classic period (A.D. 200–600), the greatest urban center of the New World. At its height, it covered an area of about eight square miles, and in it lived an estimated 100,000 persons. The population was indeed cosmopolitan, for not only was there a strong class division—with the palaces of ruler and nobles along the great north-south Avenue of the Dead, with more humble artisans, traders, and farmers residing away from this—but evidence has recently been uncovered of wards occupied by foreigners, from the Maya area, from Veracruz, and from Oaxaca. At its apogee, perhaps in the fifth century after Christ, Teotihuacán controlled the destiny of most of Mesoamerica, probably as the hub of a huge empire.

As the French archaeologist Laurette Sejourné notes, figurines occur in "astronomical numbers" in the excavations. This is, in part, the result of the introduction, most likely from coastal Ecuador in South America, of a new technique: the pottery mold. This gimmick enabled the mass production not only of figurines but also of complex incense-burners (in which many mold-made elements were put together) and relief-

decorated pottery (made of two mold-produced pieces joined together). However, almost all figurines, which are generally broken, occur in the rubbish of the city, virtually none being found in burials. In one excavated palace alone, 15,886 figurine fragments were recovered; significantly, of this lot, only eighty-four surely represent known gods, all the rest treating of mundane subjects.

The fact that most show people in the "real" world suggests that some, at least, might have formed part of household ancestor cults resembling the Lares and Penates of Rome. The finest, mold-made as well, are surely portraits, resembling in their sophistication the head of Nefertiti in Egyptian art; it is believed that all were once affixed to the bodies of dancers that are found in groups by pot-hunters. Along with these, there are women with fancy headdresses, some carrying babies on their hips, warriors in feather costumes or peering from animal masks, ball-players, trumpeters, and others who must have been common sights in the streets of the city. But the gods, although rare, are there as well: Tláloc, Tepeyóllotl (the Jaguar God), the Old Fire God, Xipe (the Flayed One, God of Spring), and a still unidentified "Fat God." Perhaps these were used in those rites involving *tepictóton* mentioned by Sahagún.

## *Jaina and the Late Classic Maya*

It is strange that, although Teotihuacán influence is strong in the Early Classic of the Maya area, figurines are unknown there at that time. However, by the Late Classic (A.D. 600–900), the art reaches the height that it once enjoyed early in the Pre-Classic. Particularly along the Gulf coast of the Yucatan Peninsula and in Tabasco, this art has few rivals.

The greater of all Maya figurines come from the tiny island of Jaina or from nearby islands to the north, just off the coast of Campeche. The only way to describe Jaina is as a cemetery, an exception to the usual rule of sub-floor burial. In fact, it is surmised from the incredible wealth of its graves, which occur in great profusion, that the noble and wealthy families of such interior centers as Uxmal and Kabah may have been taken to this island in the west for their last rites, toward the setting sun.

All Jaina figurines are hollow and most are built in two steps, the front of the piece being made in a mold, the back being built by hand and joined to the front before firing. The very greatest are entirely fashioned with the fingers. All are whistles or rattles and, as a general rule, are painted after firing with such pigments as white, red, black, and the famous "Maya blue." The really top pieces are portraits of great lords, in their own right miniature masterpieces and constituting one of the very few cases of portraiture in the native New World. These individuals may be standing or seated on thrones, with their costume and rich ornaments portrayed in loving detail; since molds could also be used for the faces, we have, as at Teotihuacán, several known portraits of what is obviously the same person.

Jaina figurines immediately recall the art of Tanagra or the T'ang Dynasty in their delicacy, detail, and sophistication; there is nothing else like them in the New World. They show the here and now, with young ladies (to whom old men are sometimes making lecherous

advances), women with children carried in the *hetzmek* fashion still seen in Yucatan today, weavers, ball-players captured in the heat of play, dancers, warriors, and nude, mutilated captives. This was a court art, and these were the activities in which the dead might be engaged in another life. In the case of the portraits, we might be in the presence of an ancestral cult, the figurine representing some distinguished personage from whom the defunct traced his lineage—we have good evidence from the Maya inscriptions on monuments that they were deeply concerned with descent.

### Post-Classic Figurines

After the Classic demise around A.D. 900, the art of *tepictóton* suffered a decline all over Mesoamerica. The lowland Maya, for instance, turned their attention to the making of idols—incense-burners in the form of gods—a trait believed to have been forced upon them by invaders from central or southern Mexico. Toltec and, following them, Aztec figurines from the Mexican *altiplano* are no rival to the wonderful Teotihuacán productions of an earlier day, although some of the same subject matter is covered and they were manufactured in the same manner, with molds.

### Other Miniatures

Art on a small scale in Mesoamerica was never confined to pottery figurines, however. The nobility and the wealthy were, from Olmec times on, patrons of the lapidary artist, who worked on a variety of hard stones, the one most preferred being jade, to fashion them into necklaces, ear ornaments, pendants, and other finery. Jade, however, was never in strong supply (a source in the stream beds of the Motagua River of Guatemala has been located in recent years), so other stones with the desired greenish hue were sought. The finest of all jades from Mesoamerica are the magnificent Olmec miniatures, which were often fashioned from a beautiful blue-green variety whose source has never been found; these are truly *objets de vertù*, with an aesthetic and real value that sets them far above the art of the figurine-maker.

Later on, with the exception of early Classic Teotihuacán and the lowland Maya of the late Classic period, lapidary standards seem to have fallen, along with a decline in the amount of jade available. The Classic and Post-Classic examples shown here exhibit a kind of reductionism resulting from this trend, some of the pendants merely being little plates of green stone, with features economically indicated by half-circles produced by a hollow drill. It is a tribute to the strength of artistic traditions in Mesoamerica that they still have some aesthetic interest to us.

MICHAEL D. COE

SELECTED BIBLIOGRAPHY

COE, MICHAEL D.

*The Jaguar's Children: Pre-Classic Central Mexico*. New York: The Museum of Primitive Art, 1965.

COVARRUBIAS, MIGUEL

*Indian Art of Mexico and Central America*. New York: Alfred A. Knopf, 1957.

GROTH-KIMBALL, IRMGARD

*Mayan Terracottas*. New York: Frederick A. Praeger, 1961.

INFORMANTES DE SAHAGÚN

*Ritos, Sacerdotes y Atavíos de los Dióses*. Mexico: Universidad Nacional Autónoma de México, 1958.

PORTER, MURIEL NOÉ

"Excavations at Chupícuaro, Guanajuato, Mexico." *Transactions of the American Philosophical Society*, vol. 46, pt. 5. Philadelphia: 1956.

SEJOURNÉ, LAURETTE

*El lenguaje de las formas en Teotihuacán*. Mexico: 1966.

TORQUEMADA, FRAY JUAN DE

*Monarquía Indiana*. Mexico: Chávez Hayhoe, 1943.

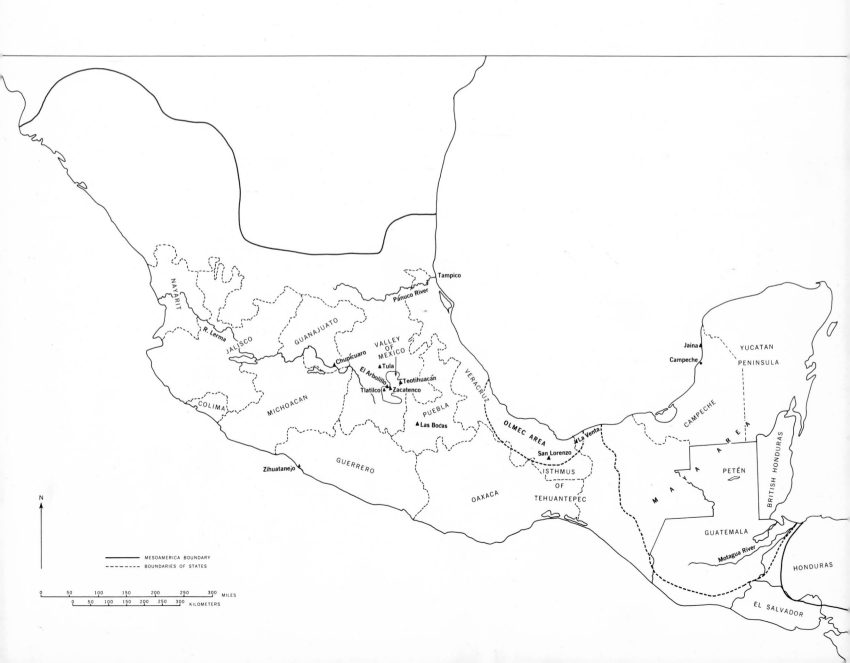

Pre-Classic Valley of Mexico

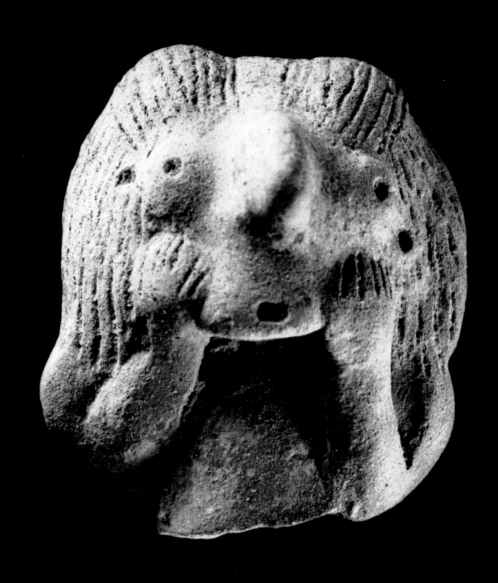

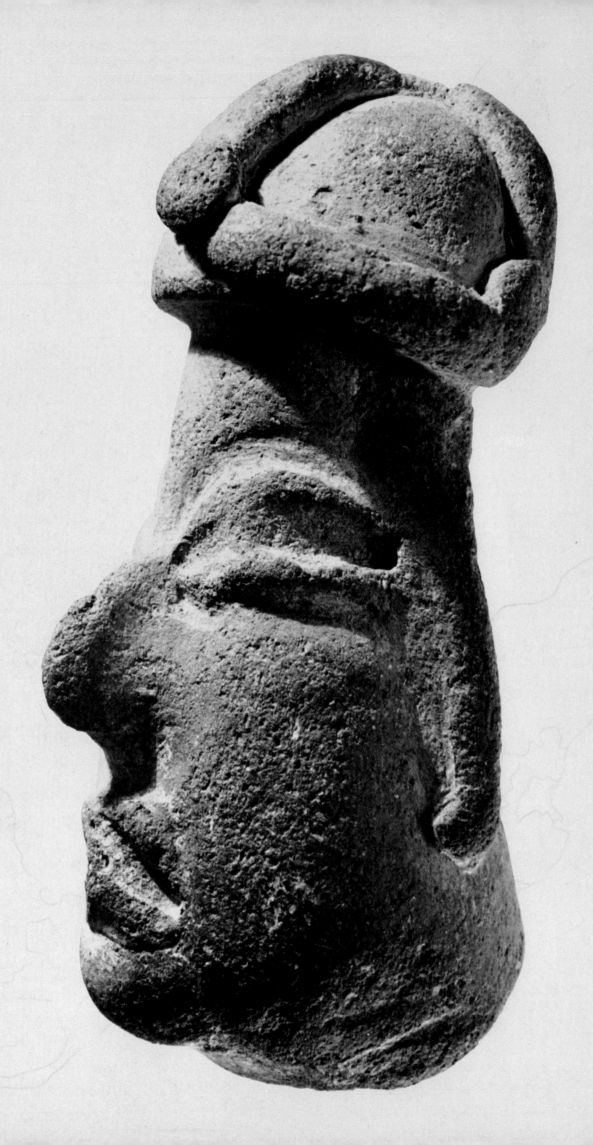

2

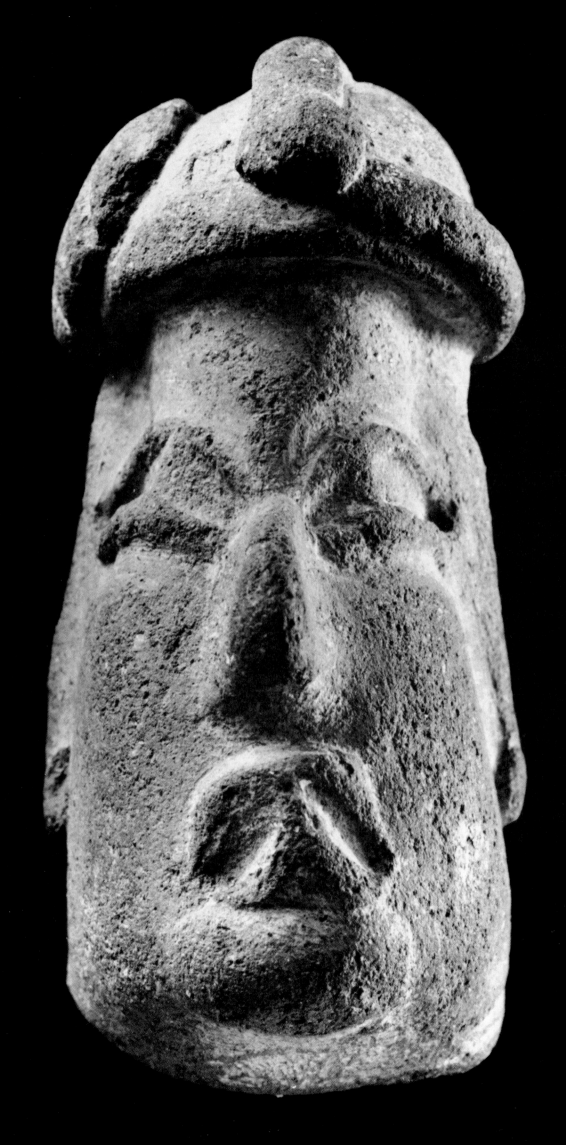

3

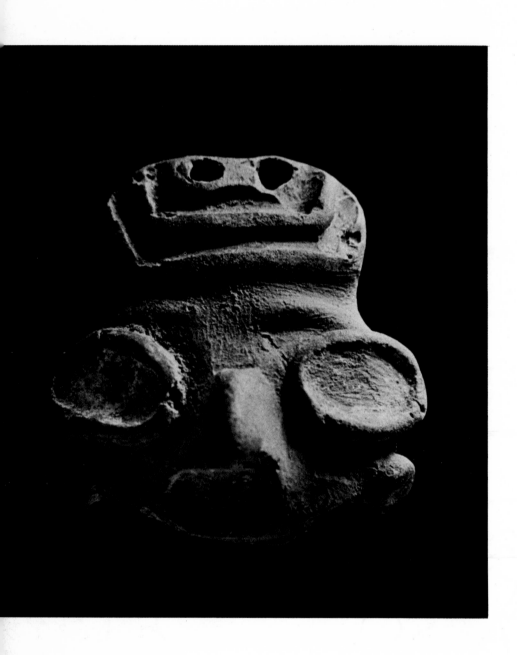

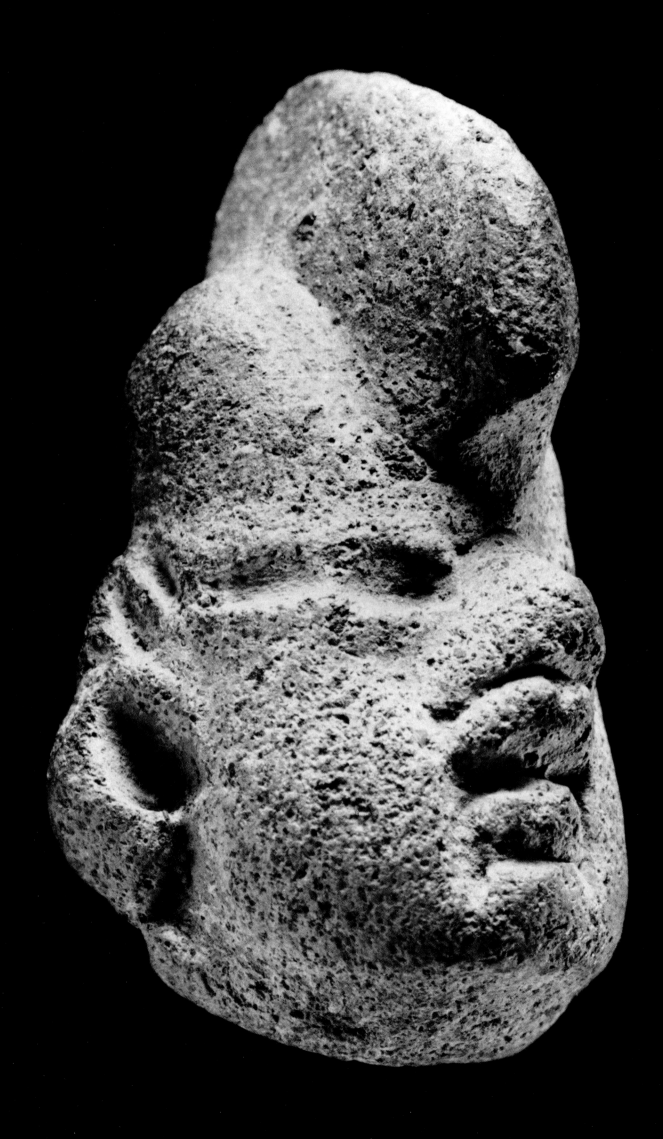

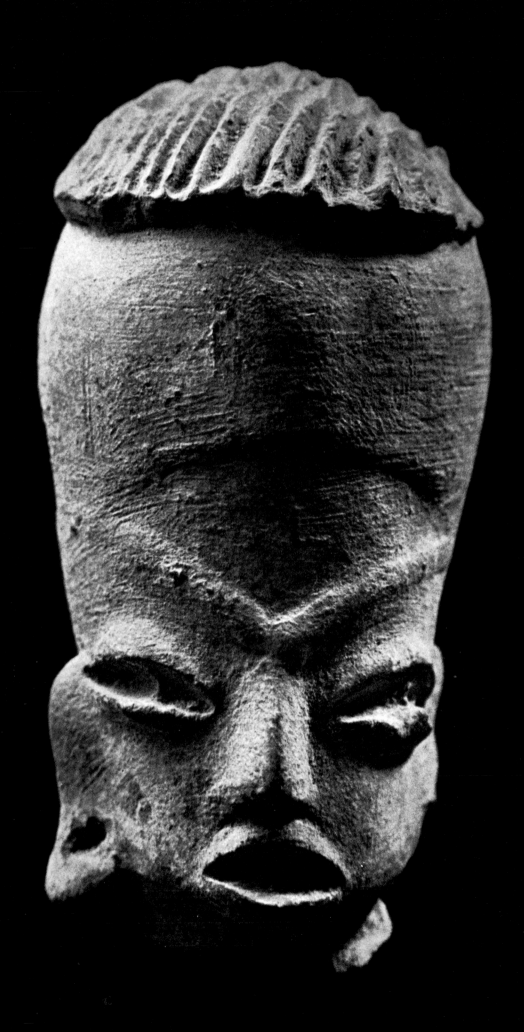

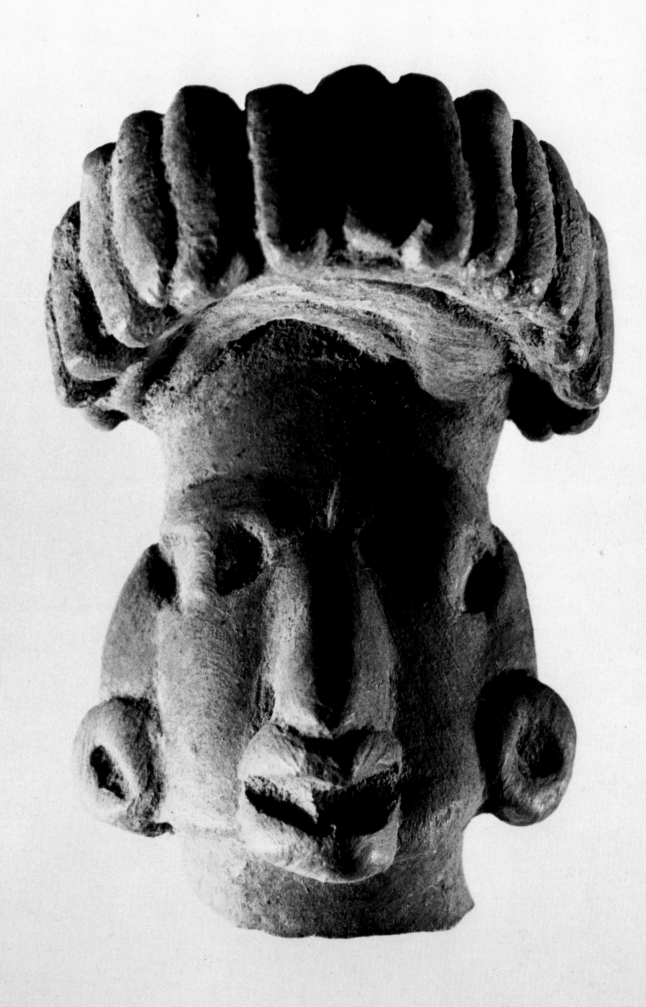

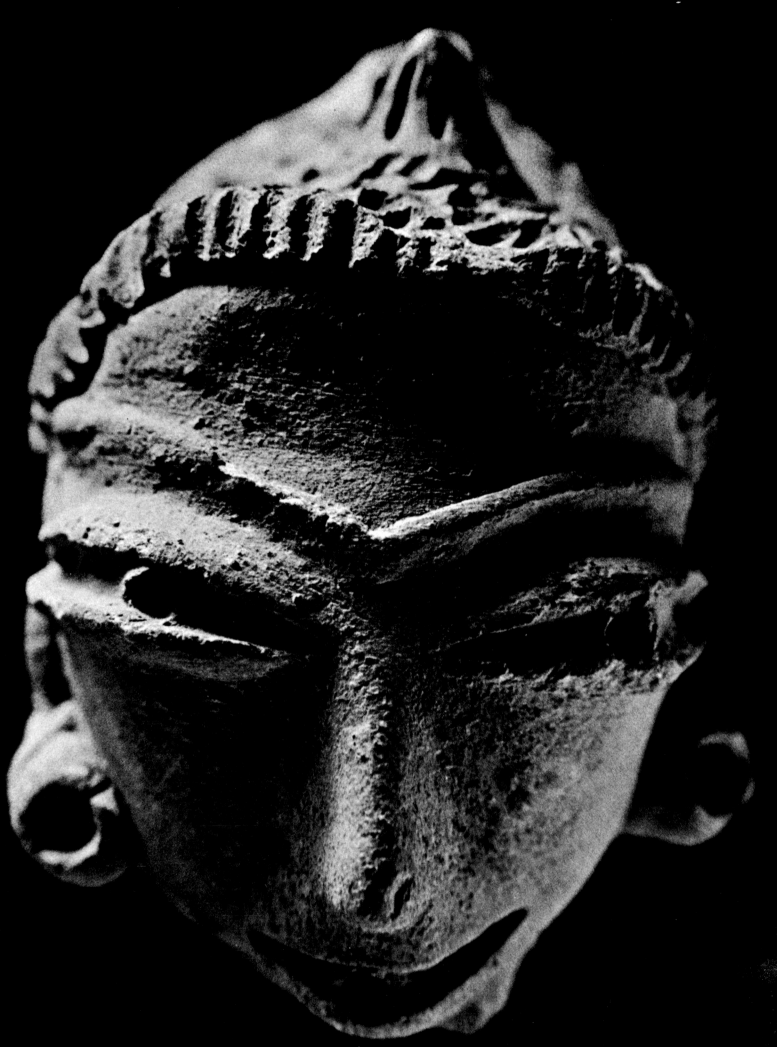

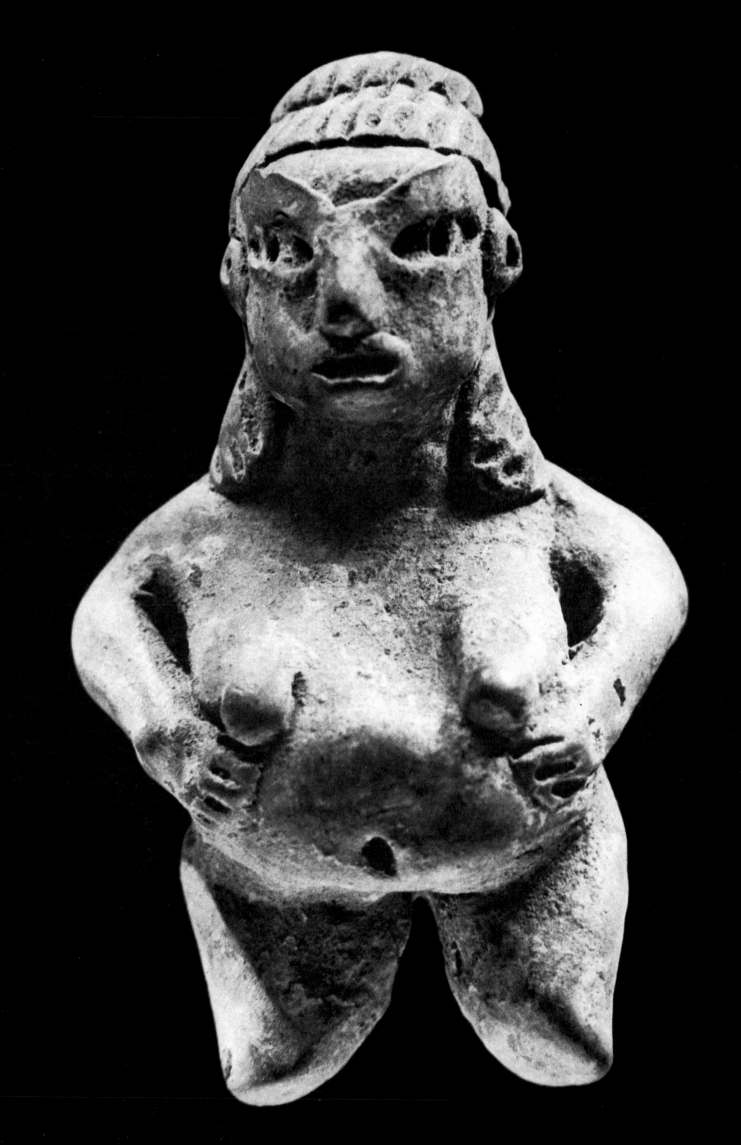

9

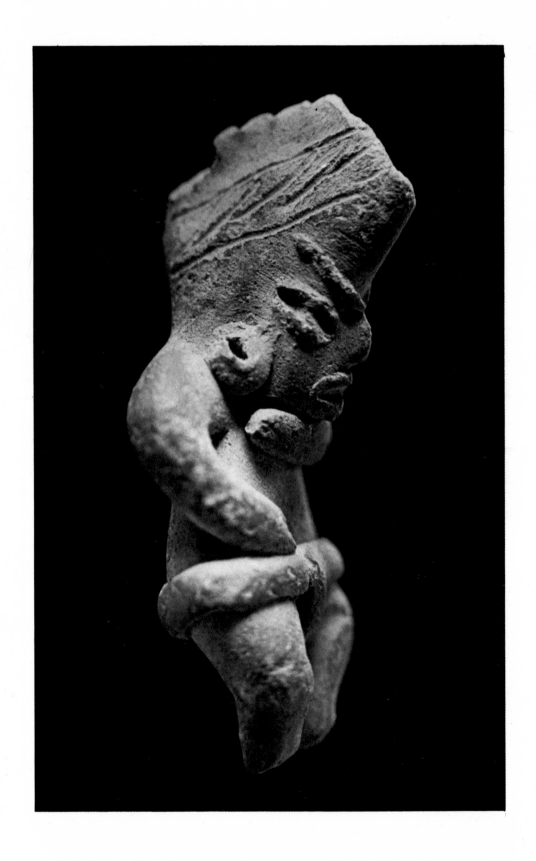

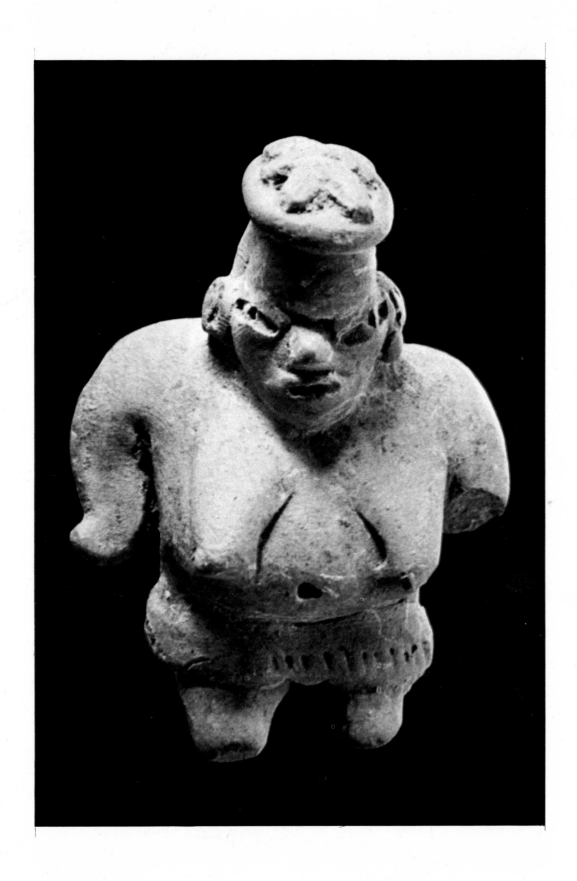

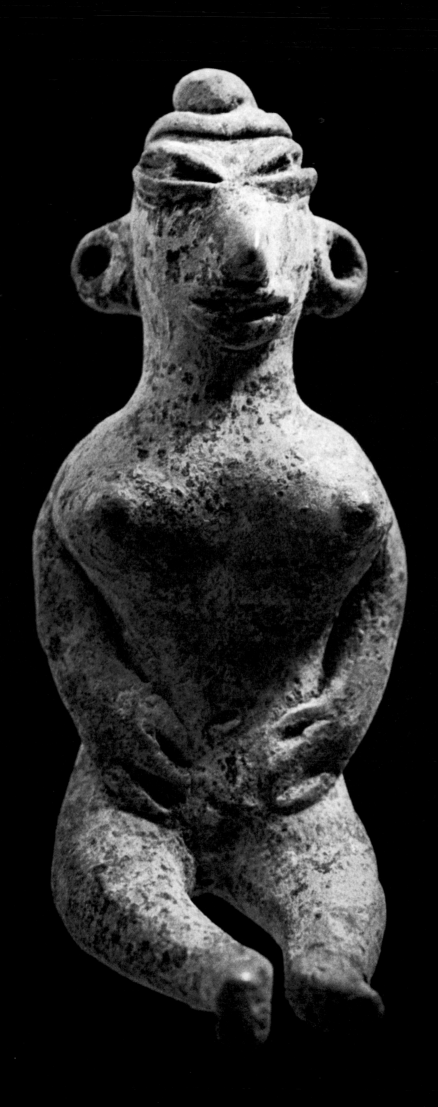

12

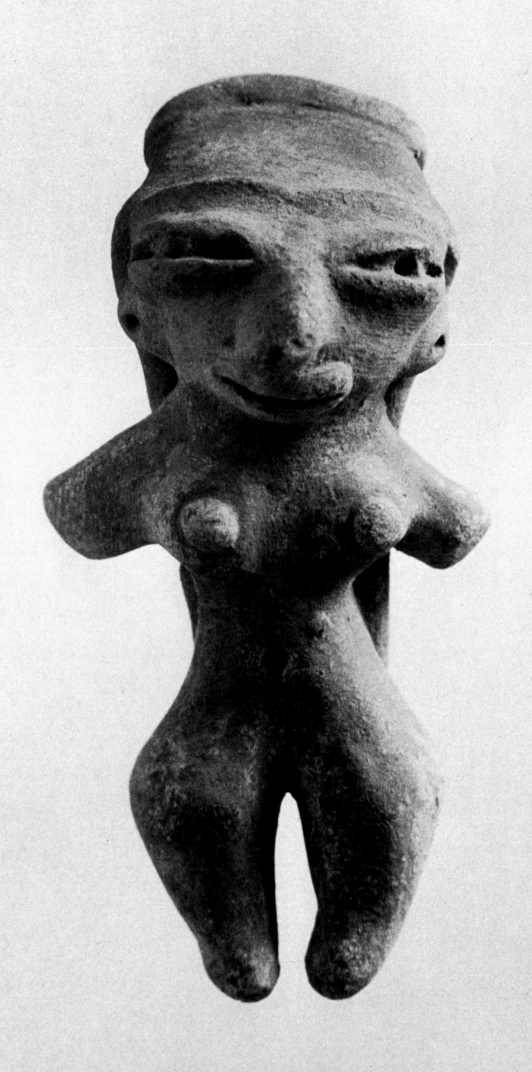

13

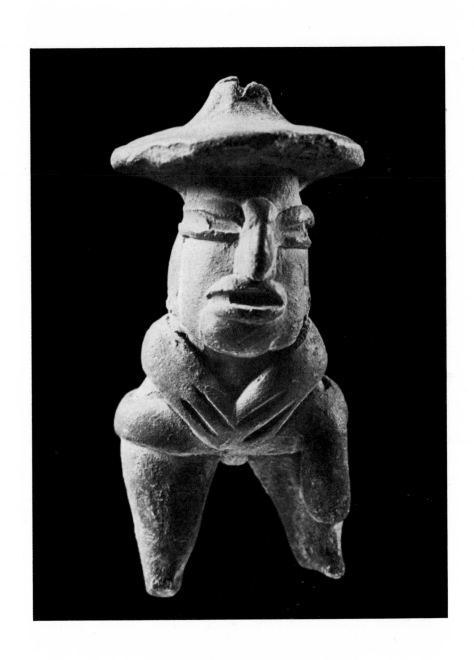

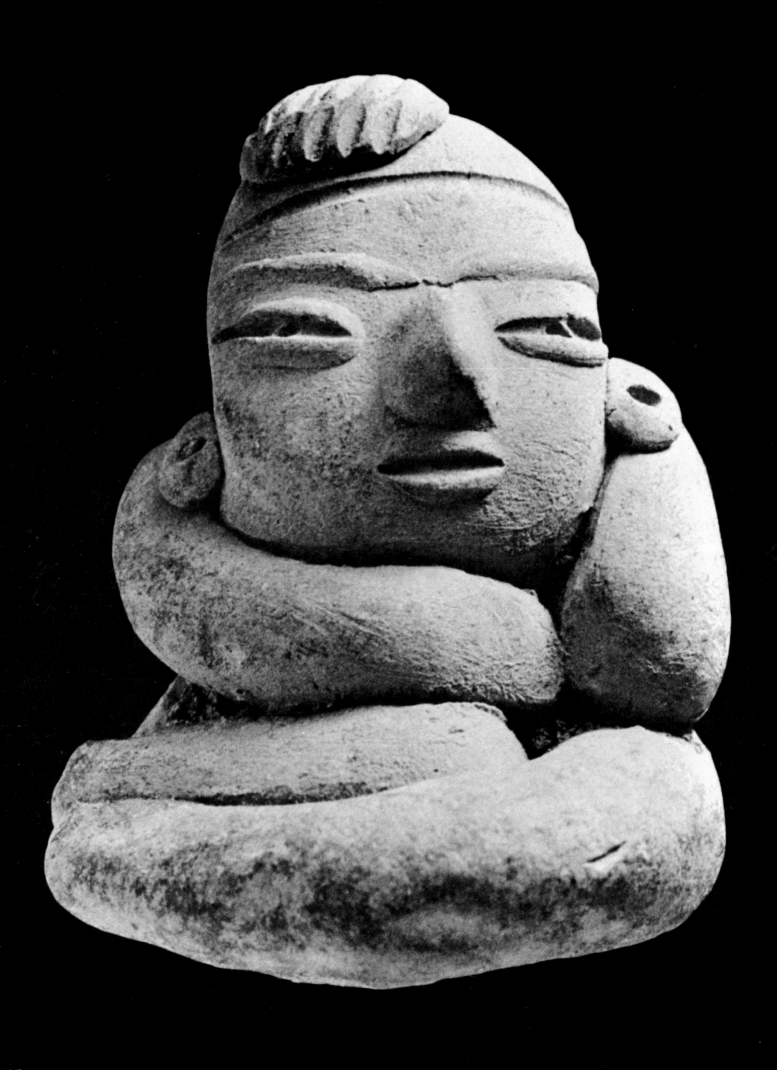

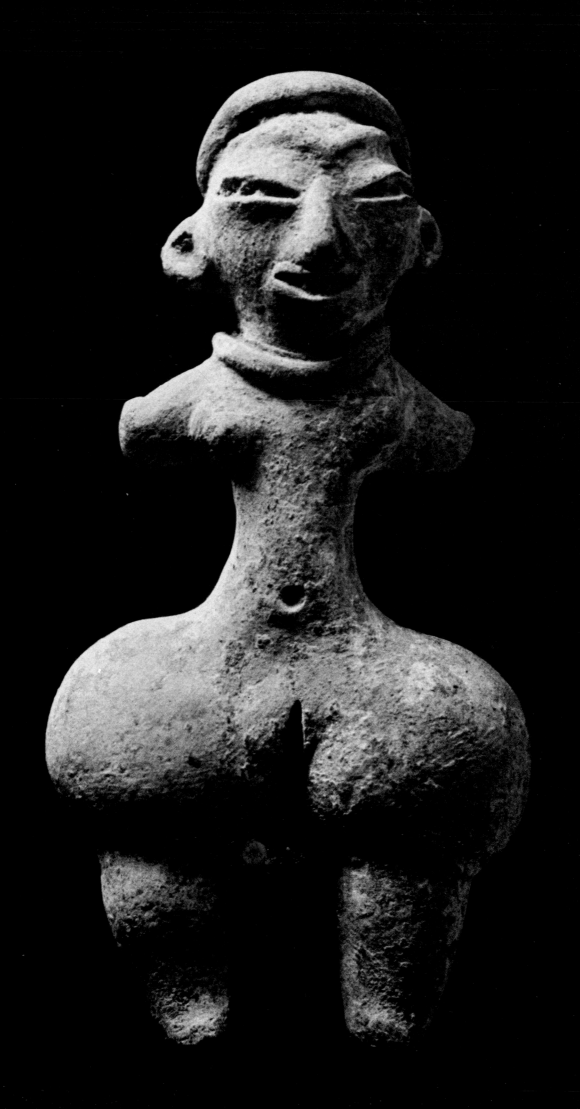

16

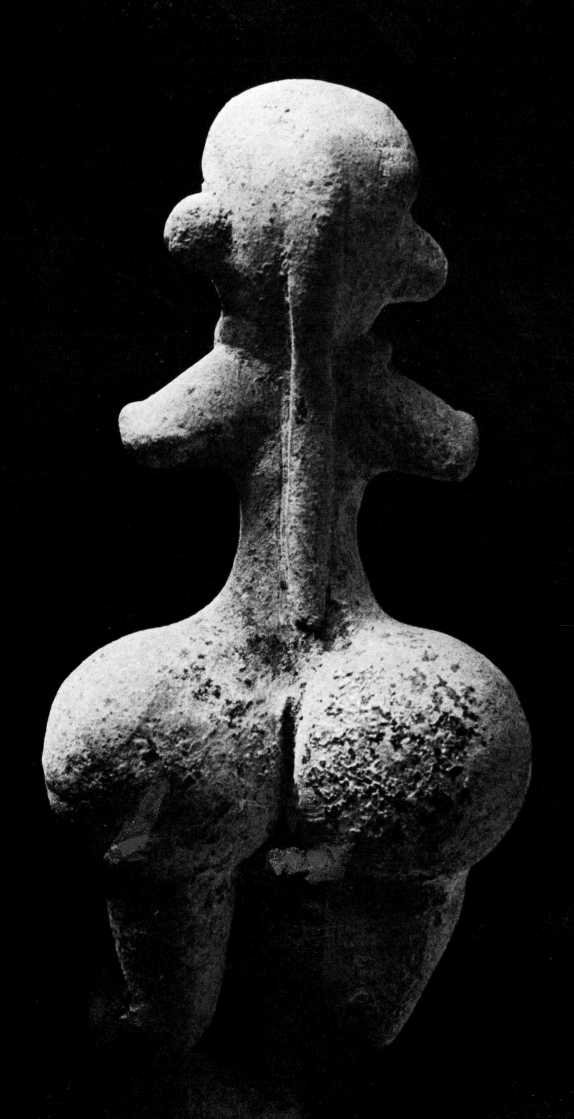

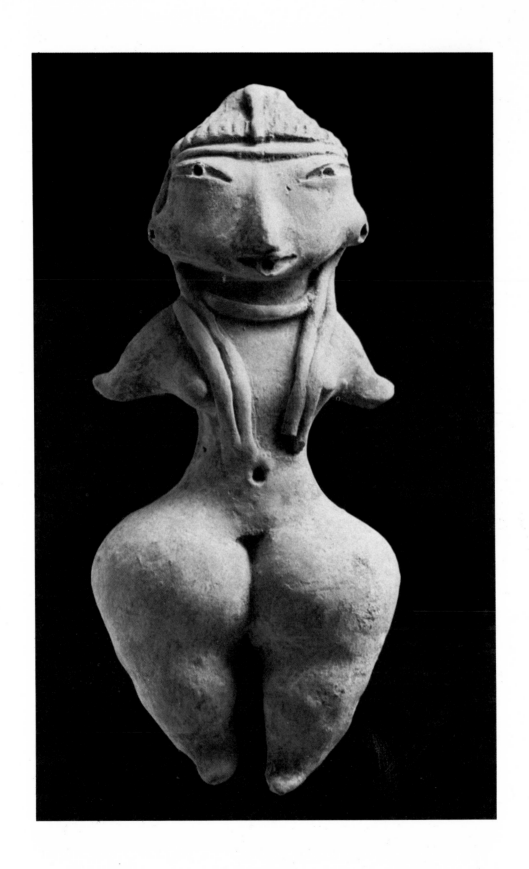

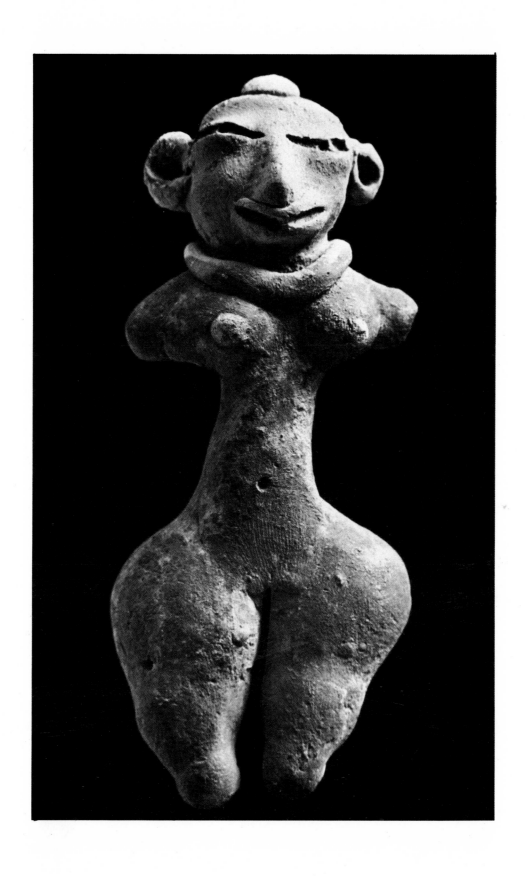

19

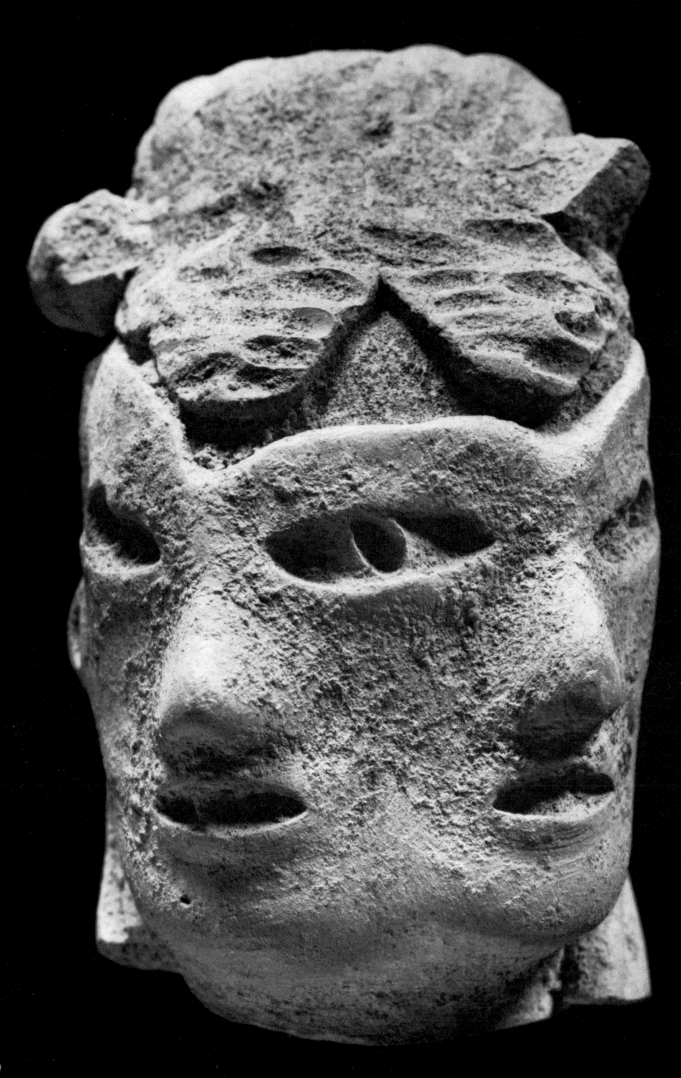

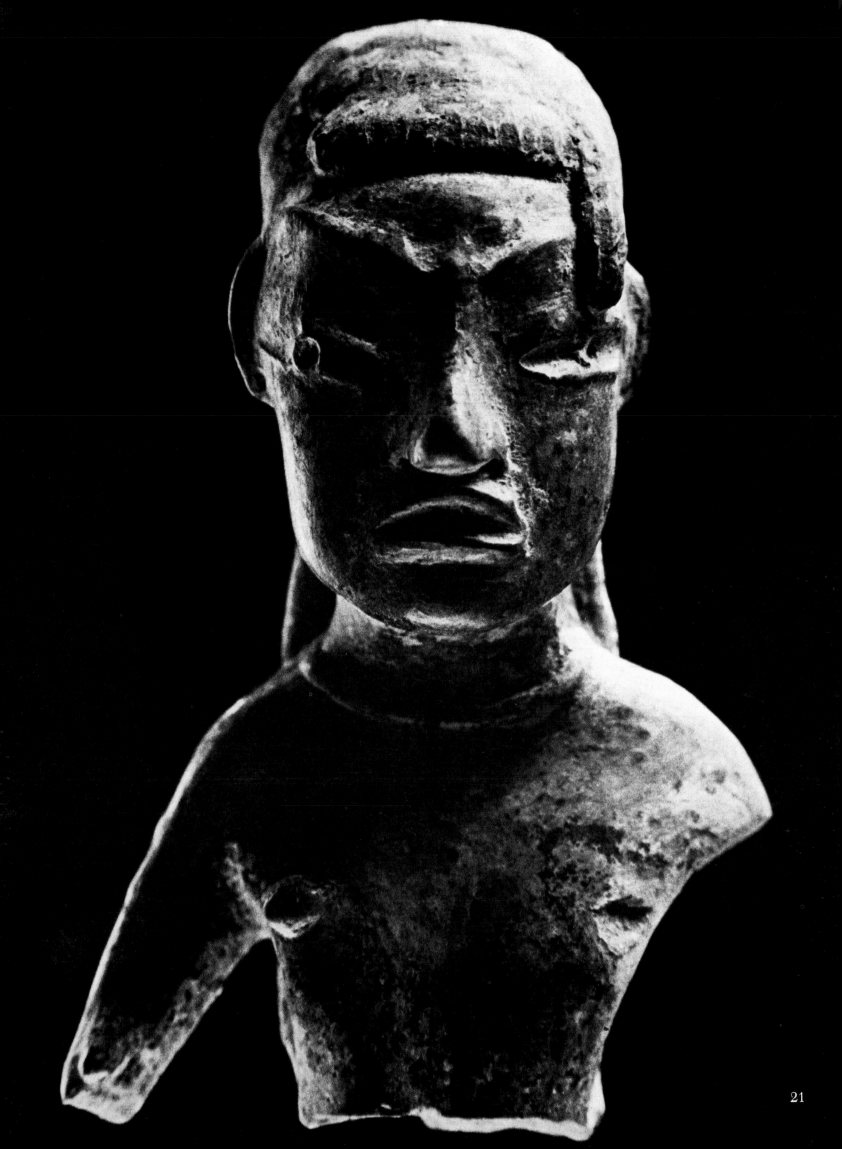

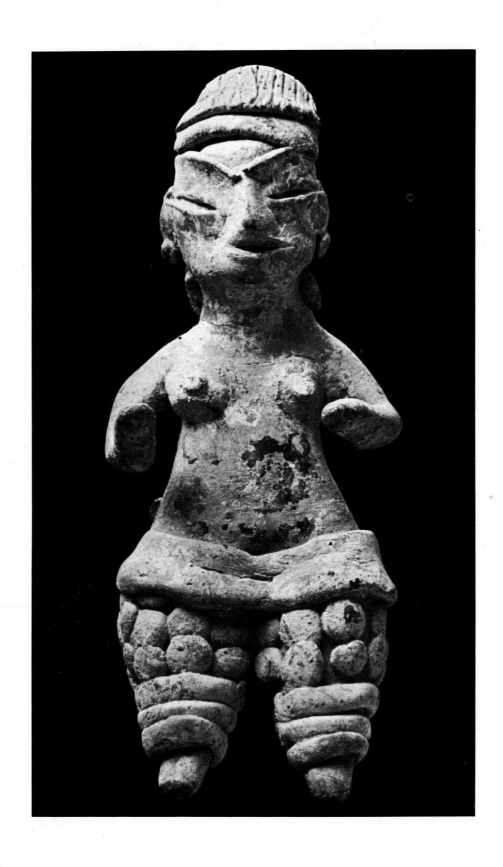

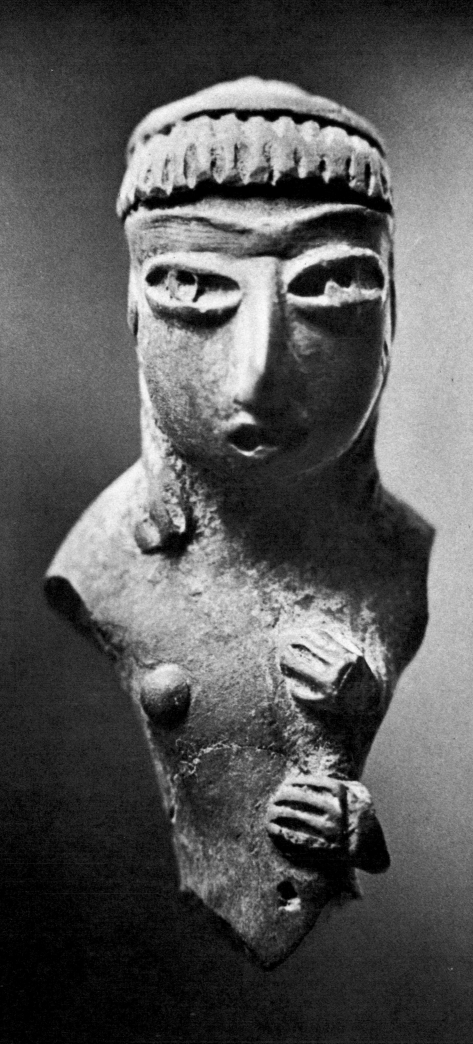

23

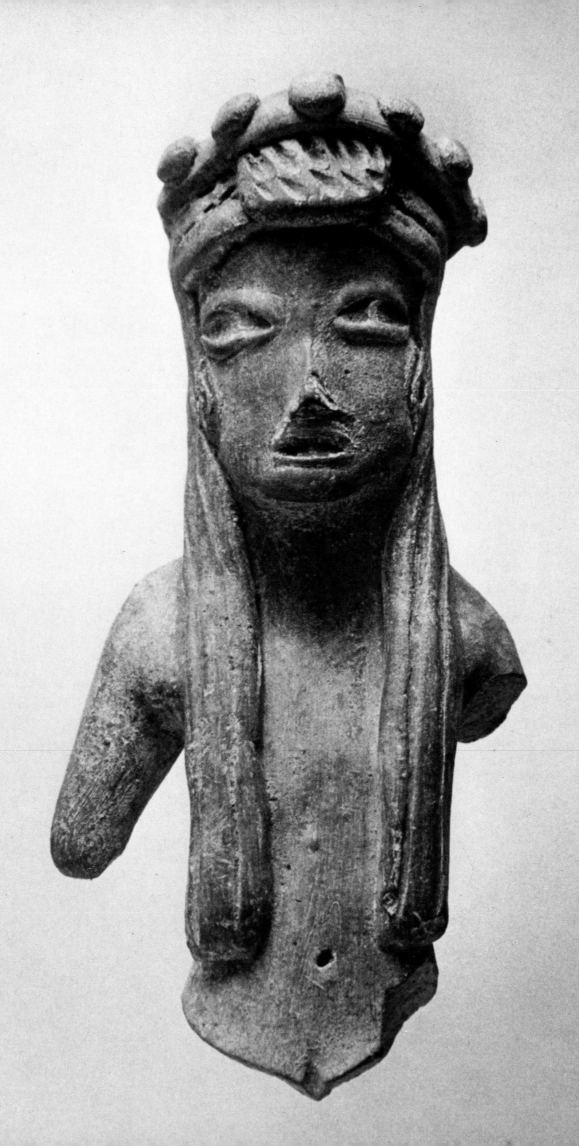

Chupícuaro

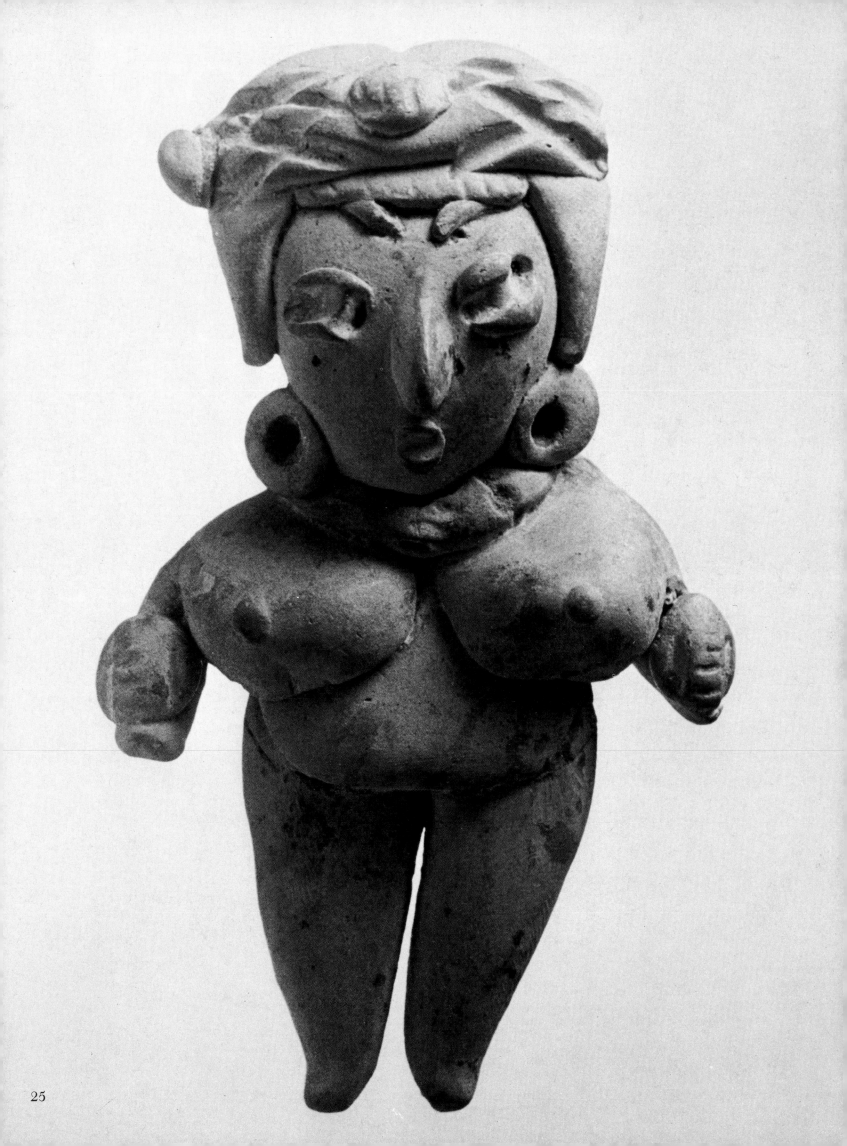

25

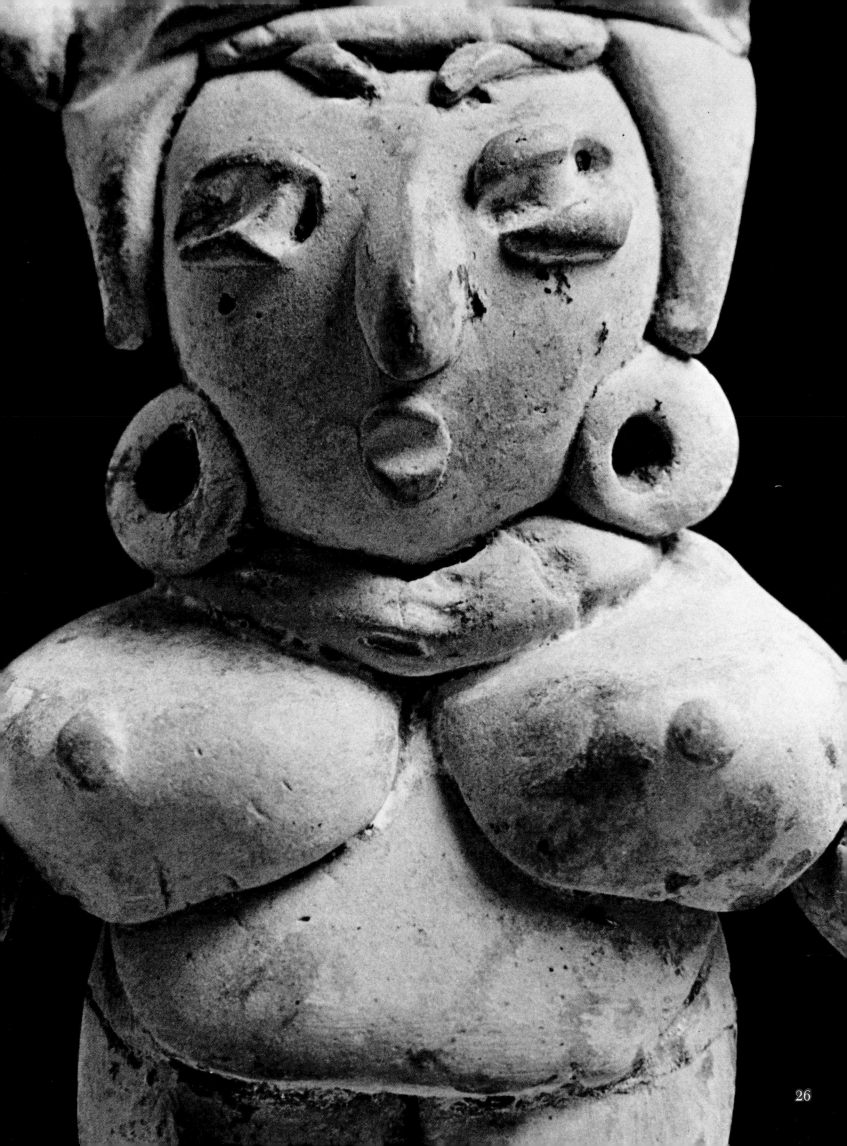

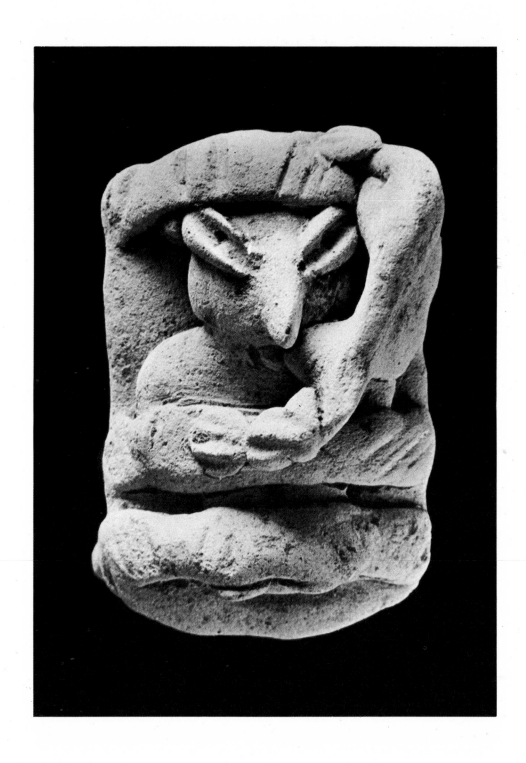

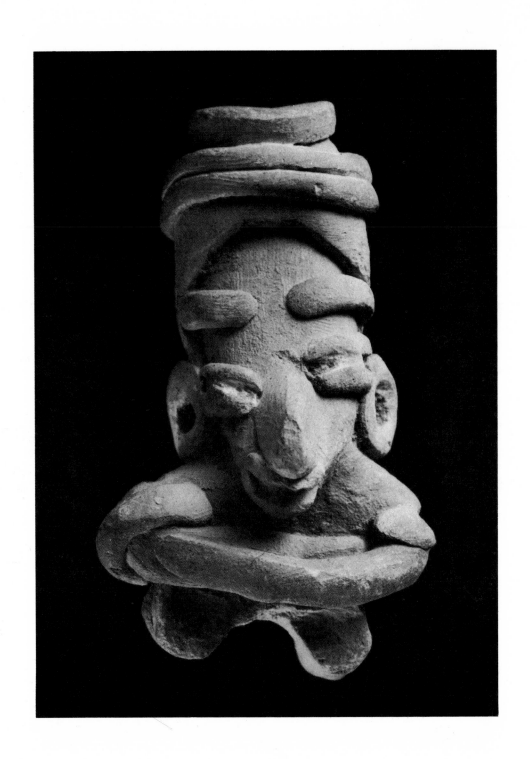

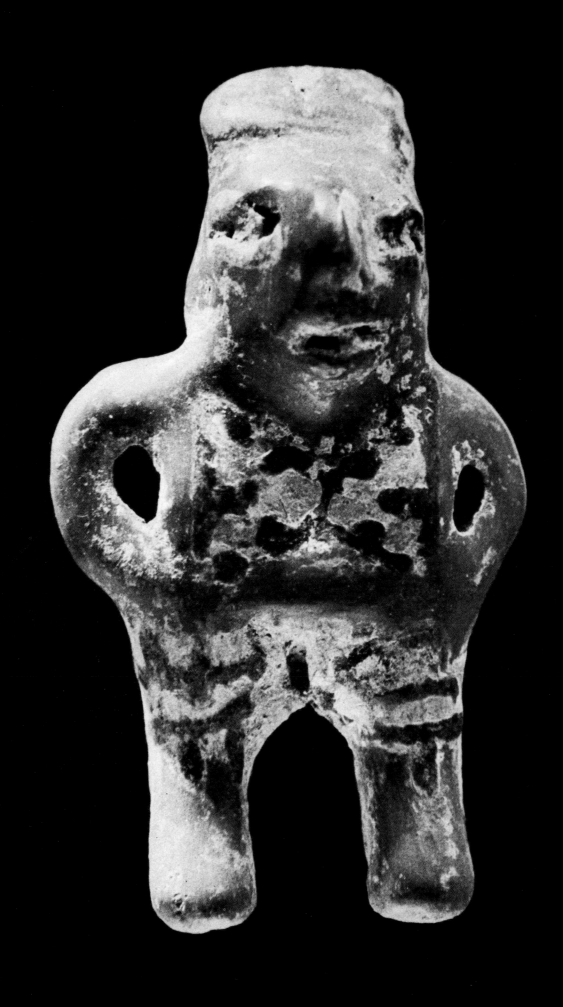

29

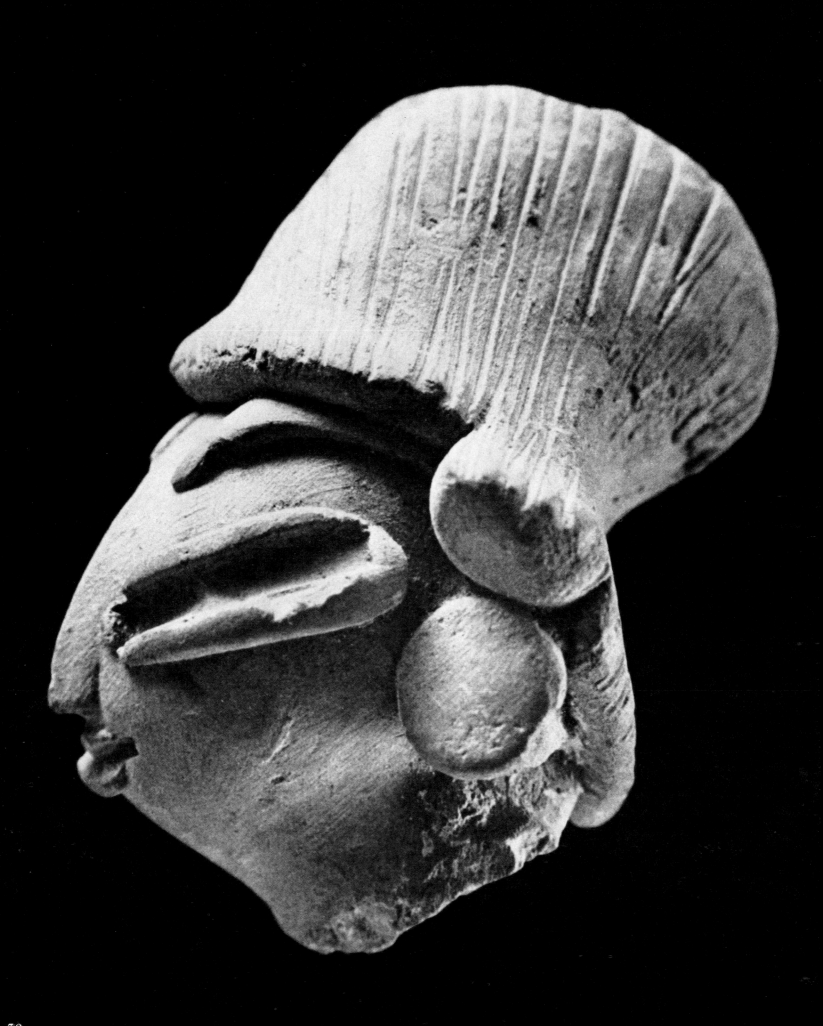

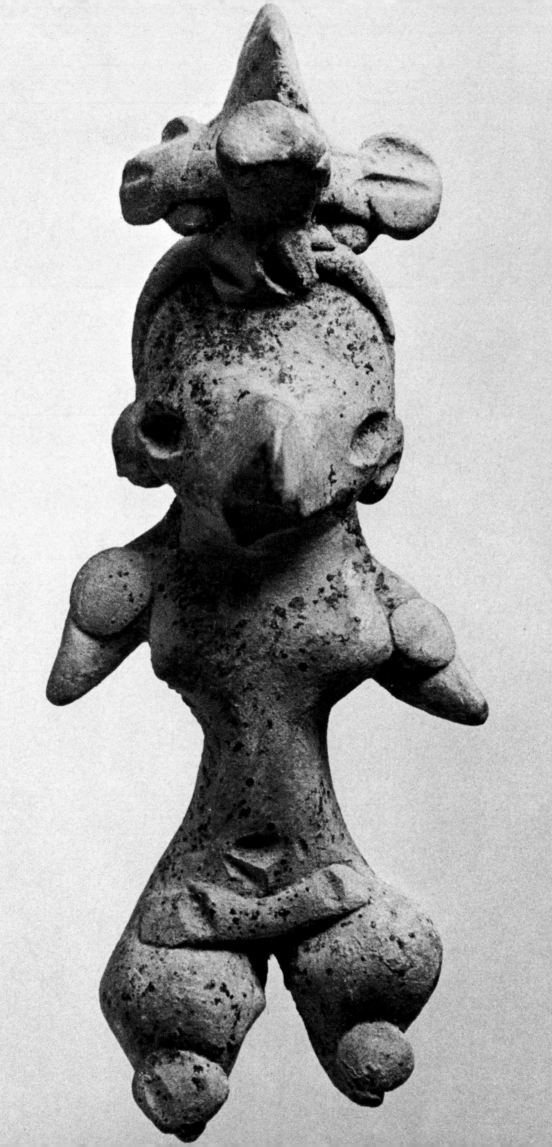

31

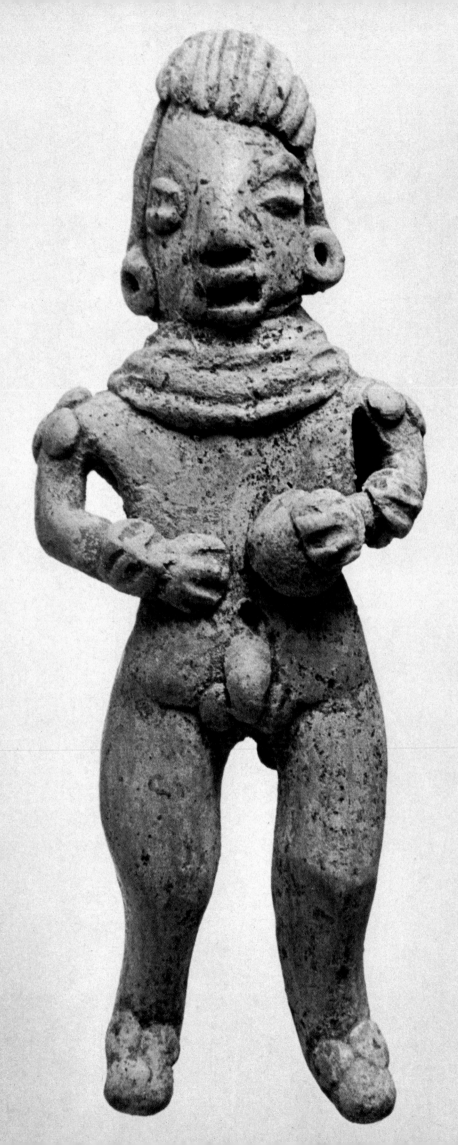

32

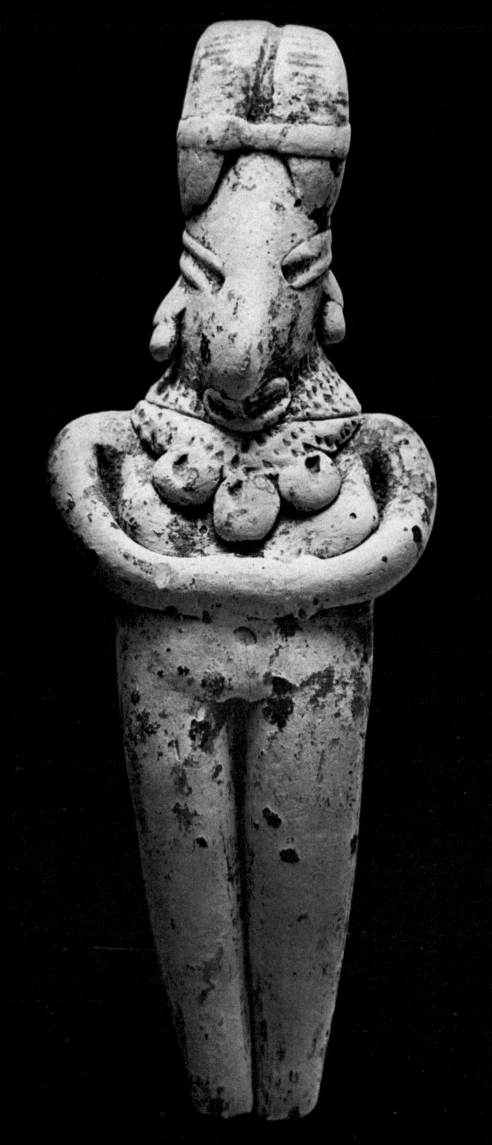

33

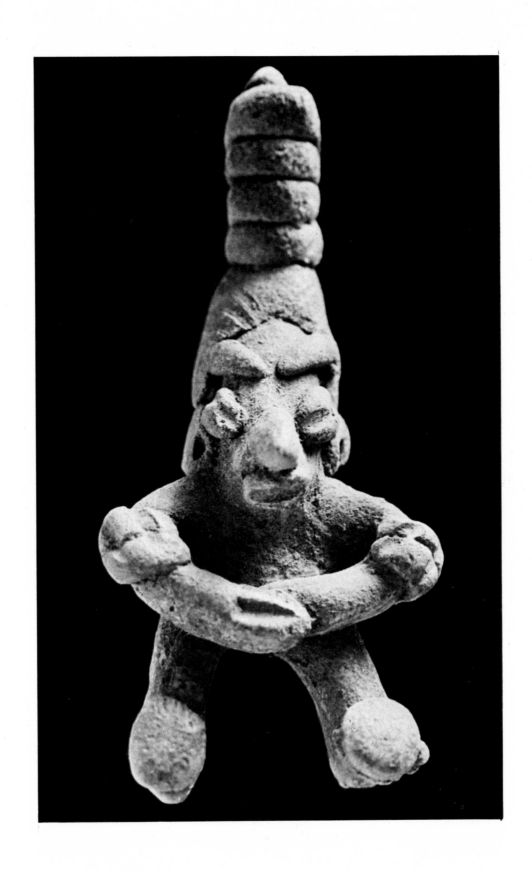

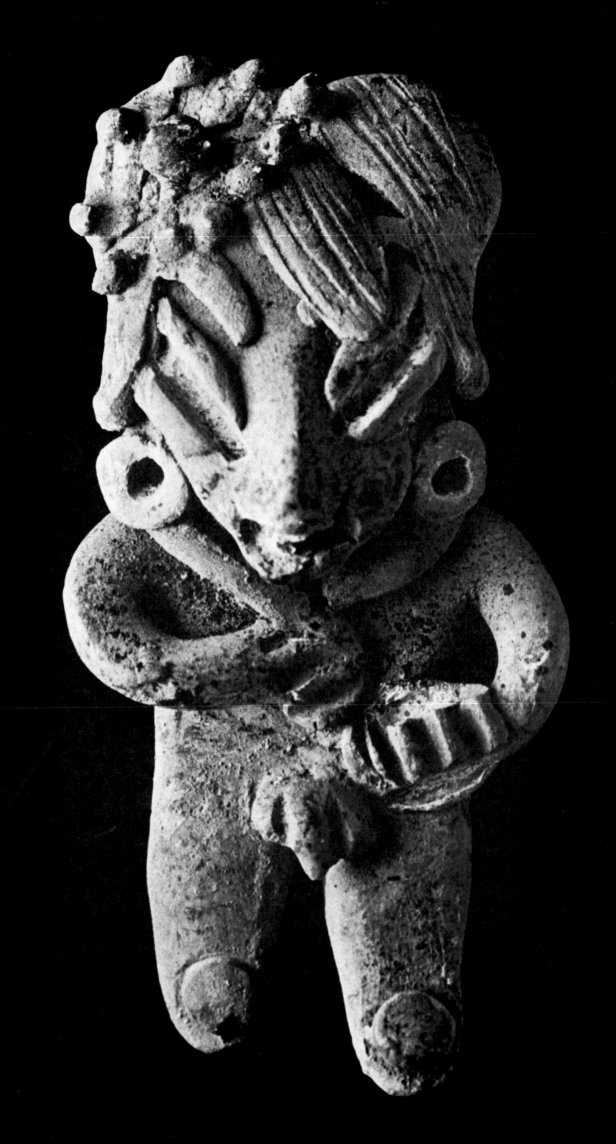

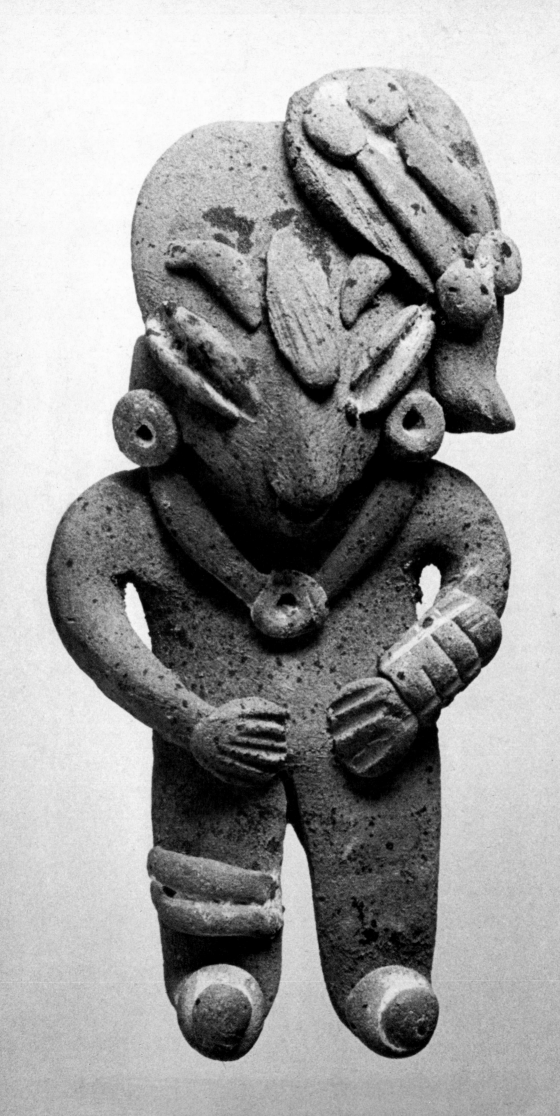

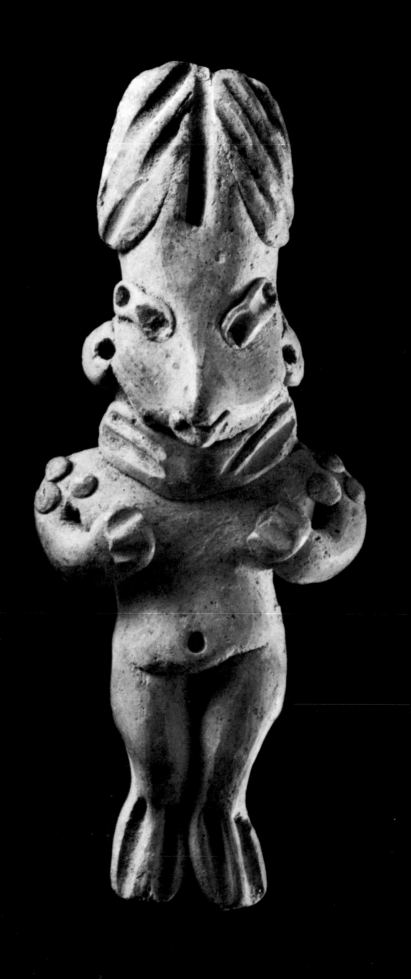

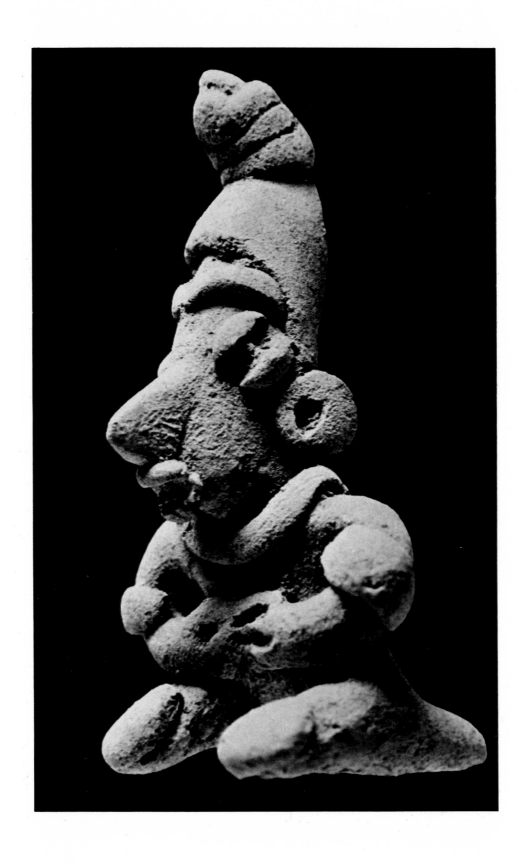

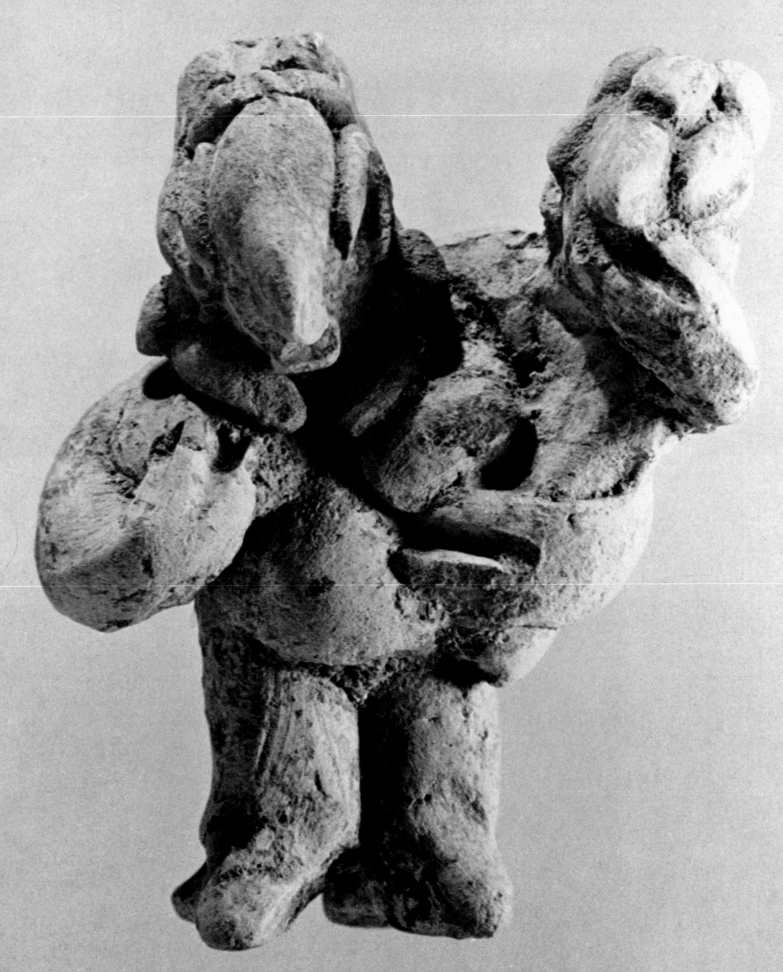

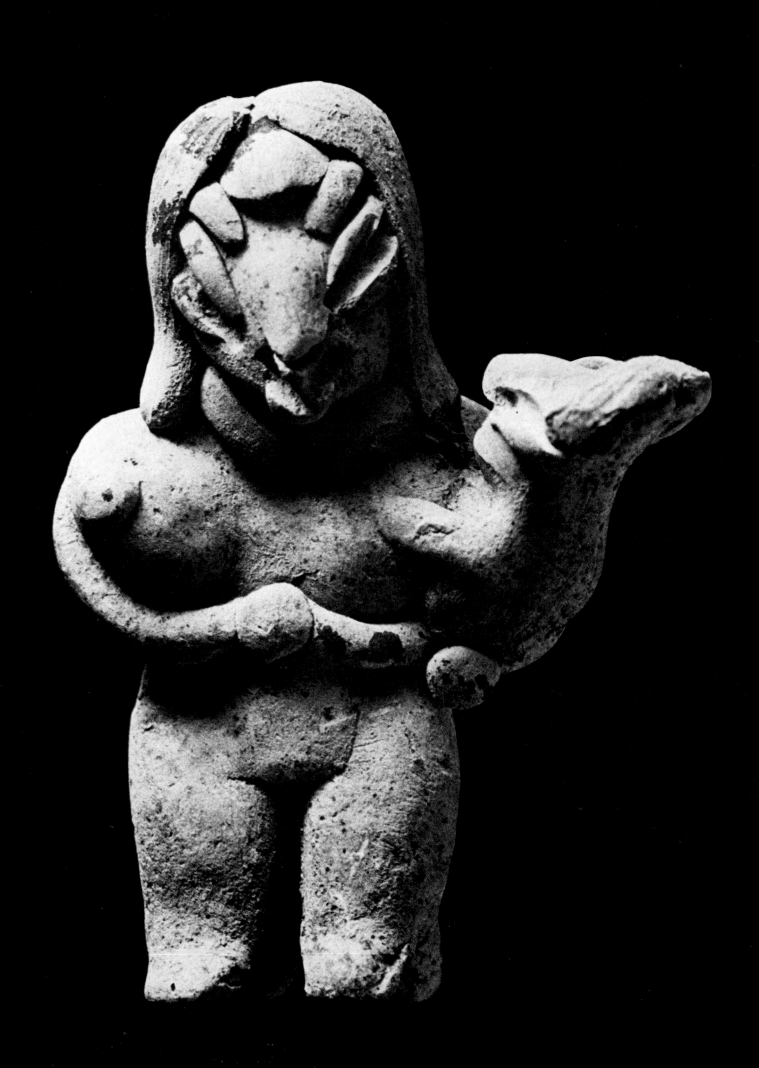

40

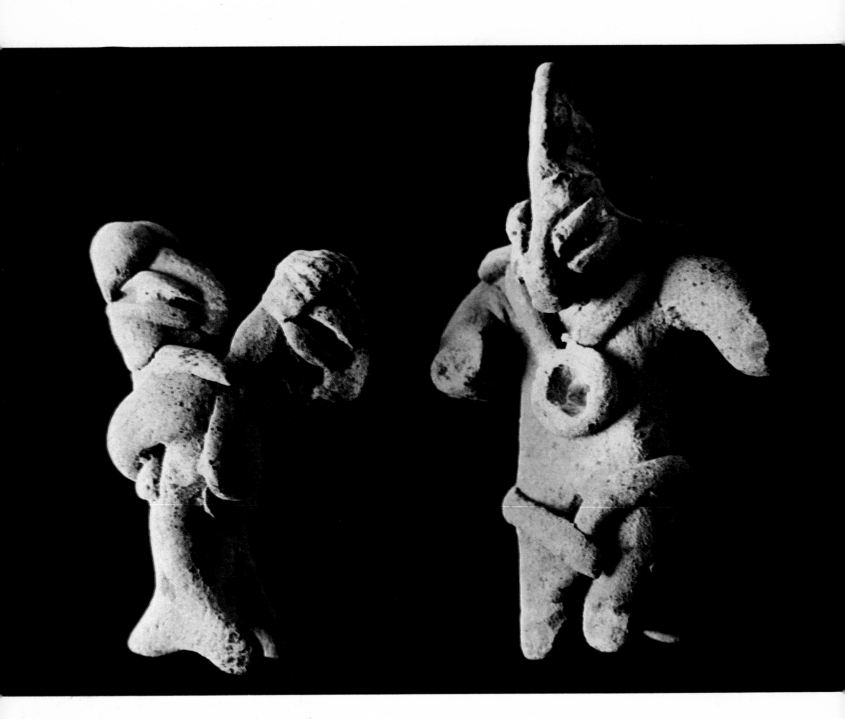

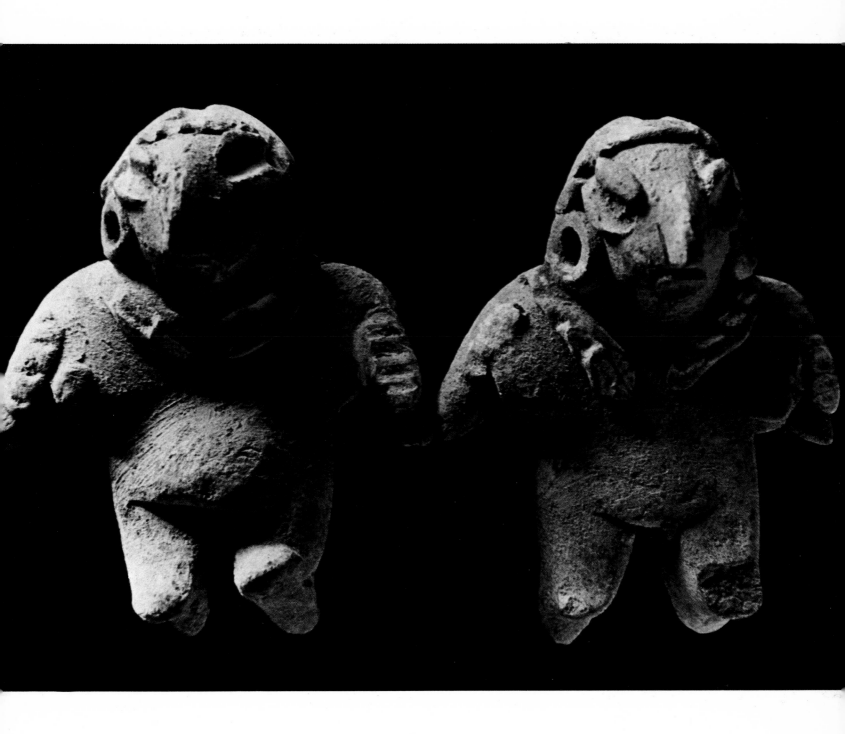

# Michoacán and Guerrero (*Pre-Classic*)

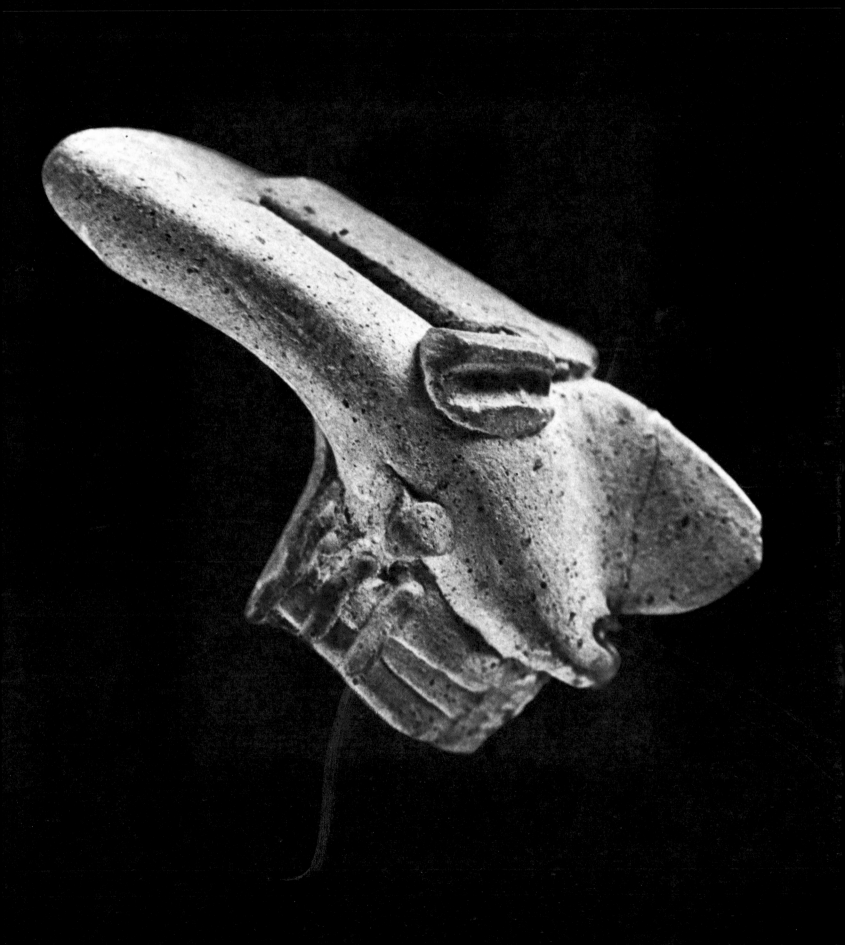

43

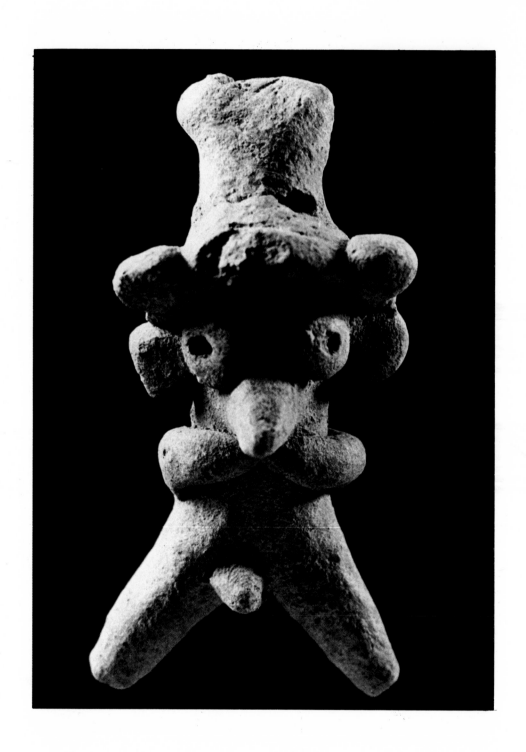

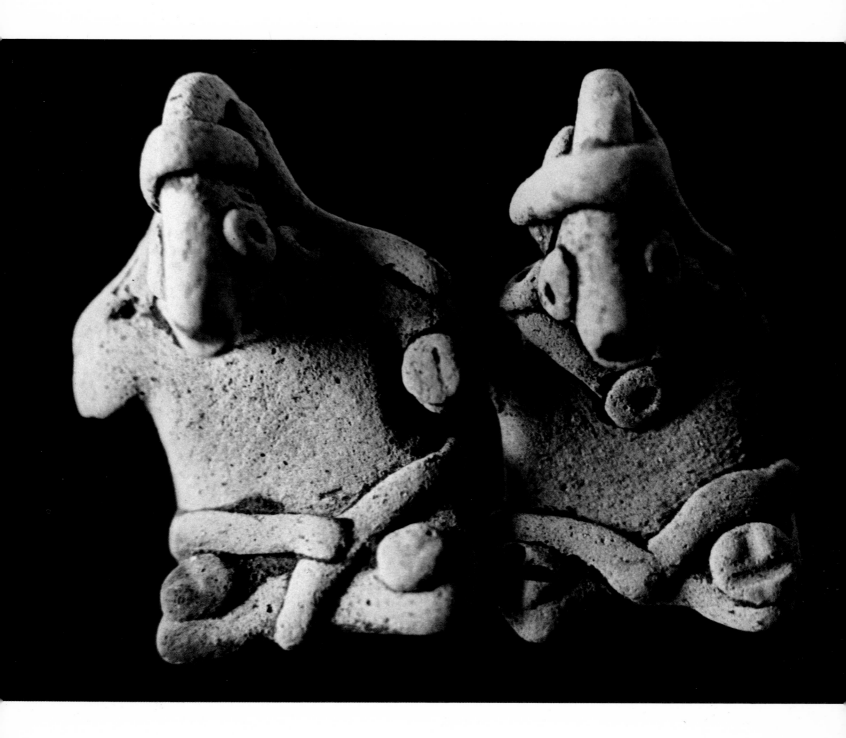

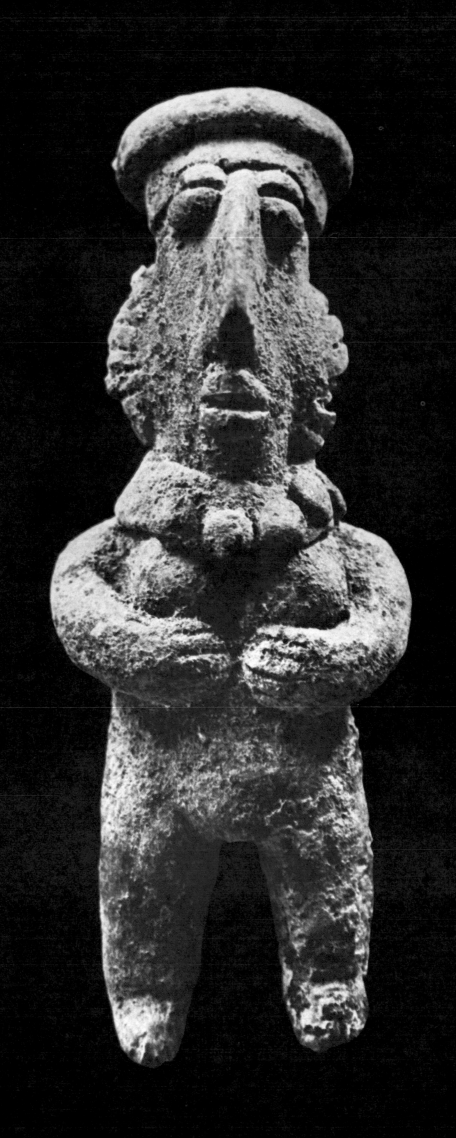

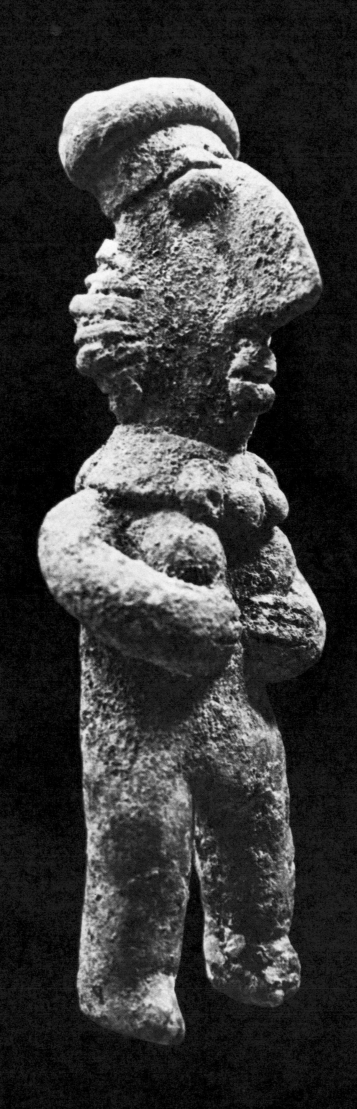

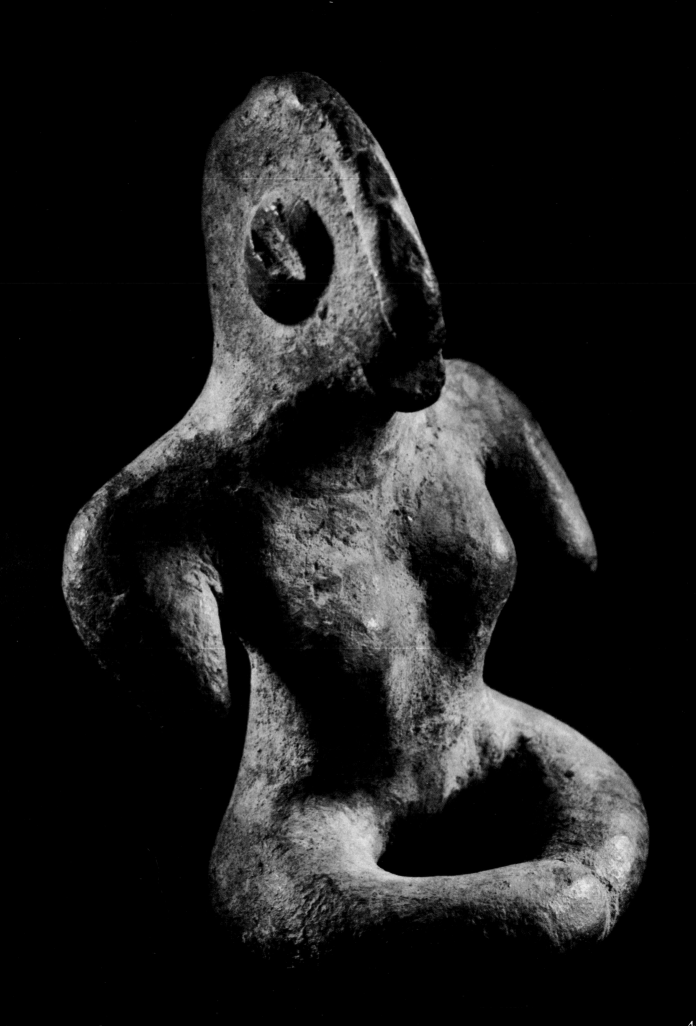

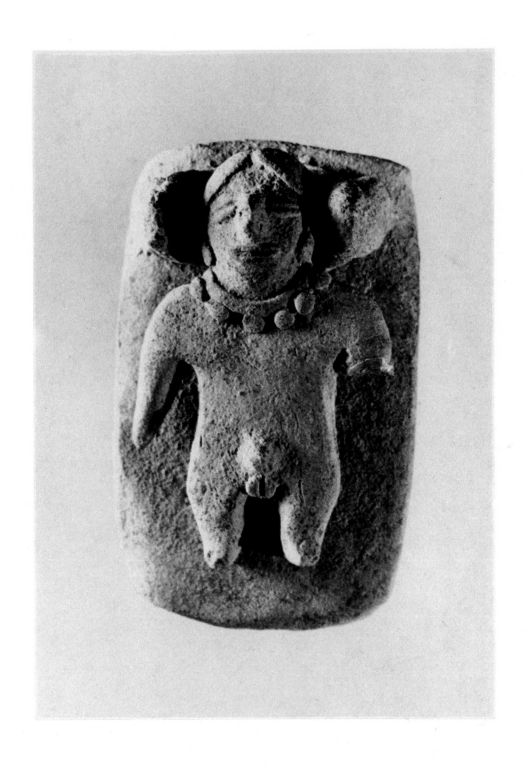

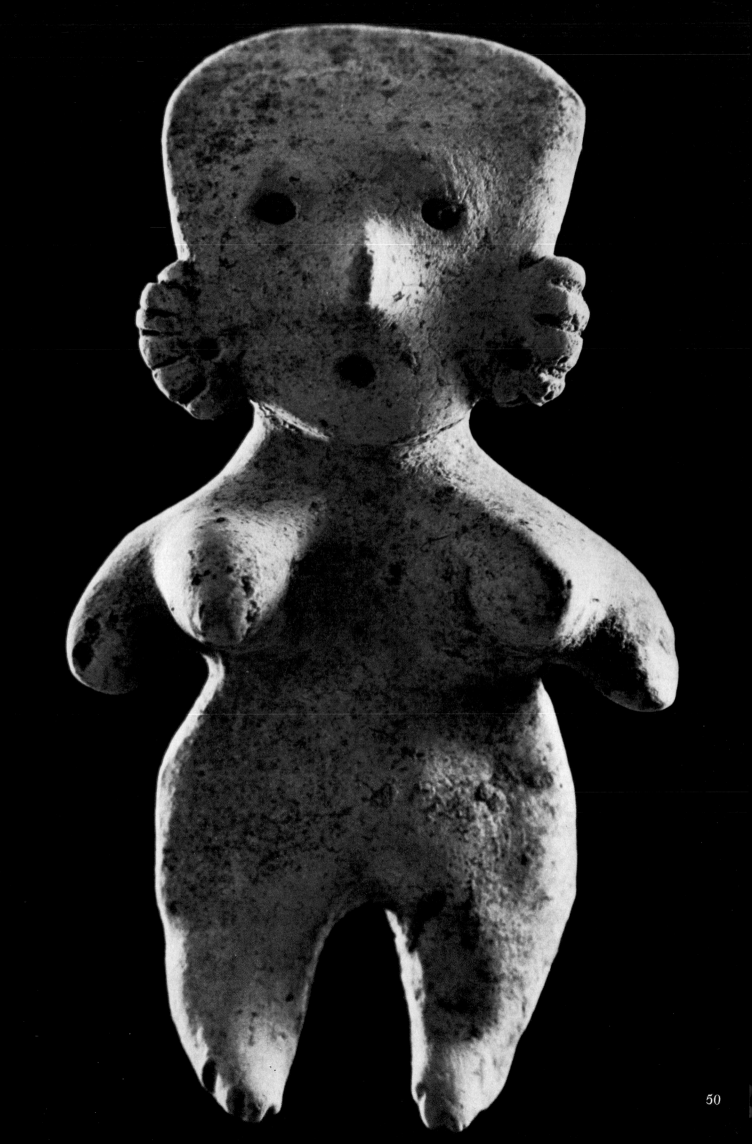

50

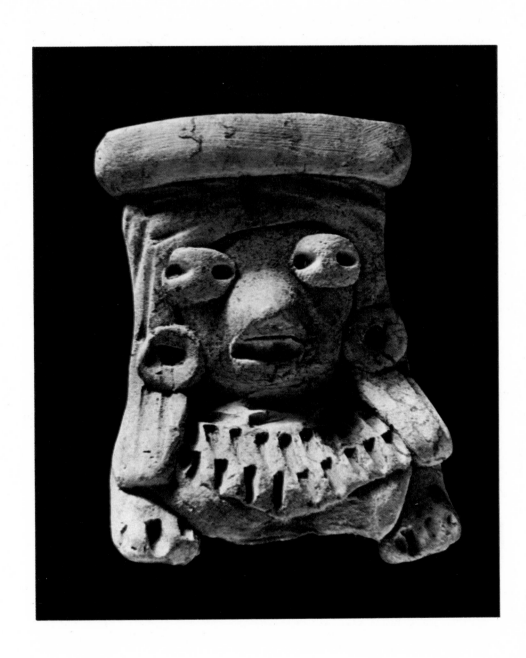

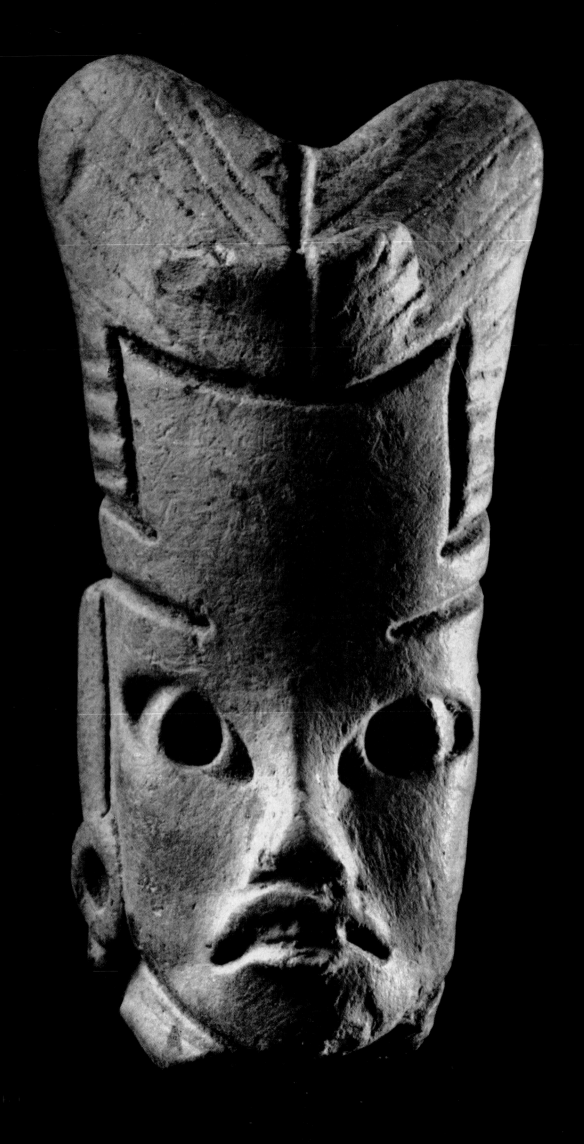

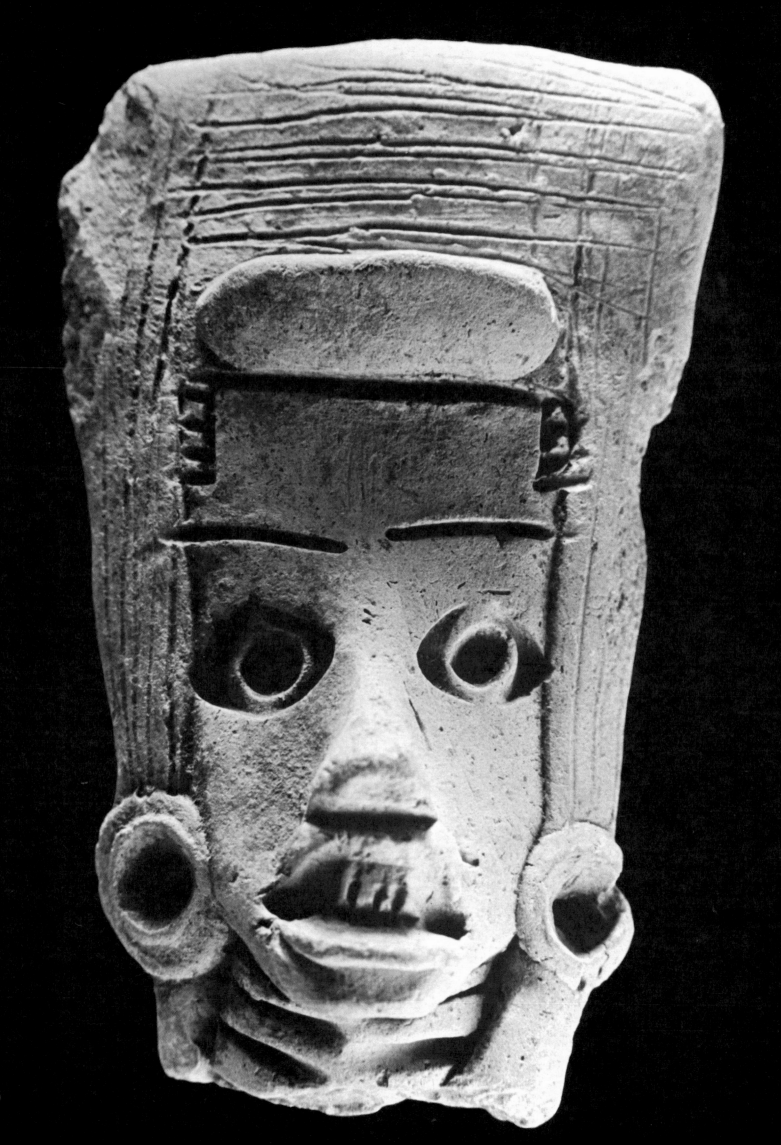

53

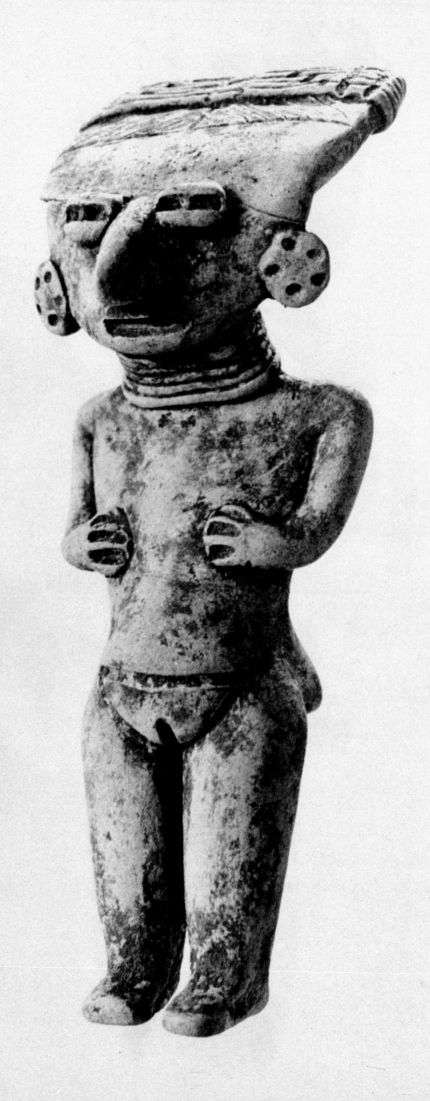

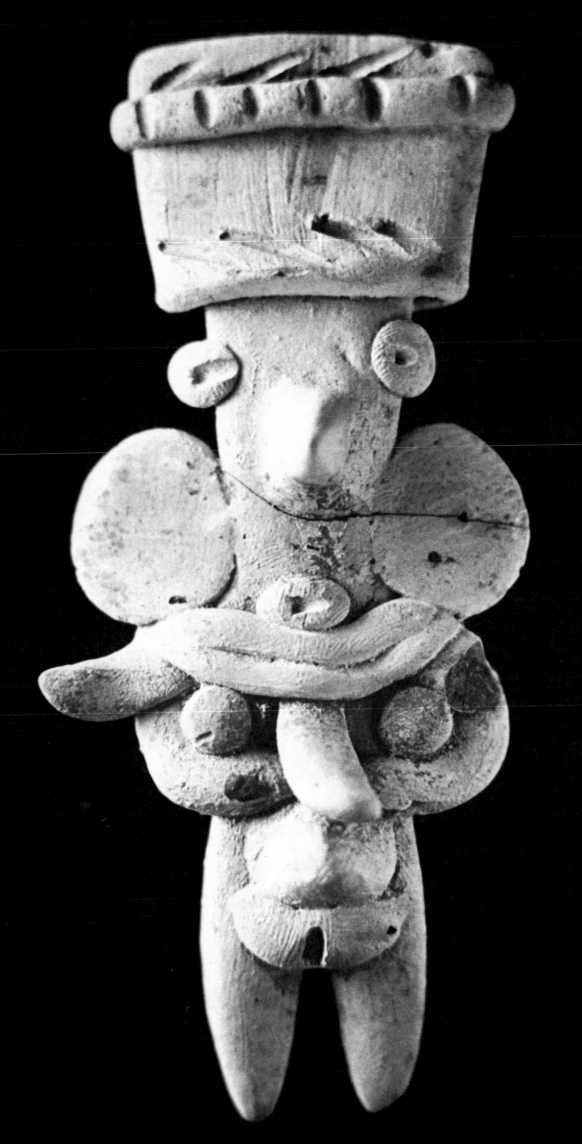

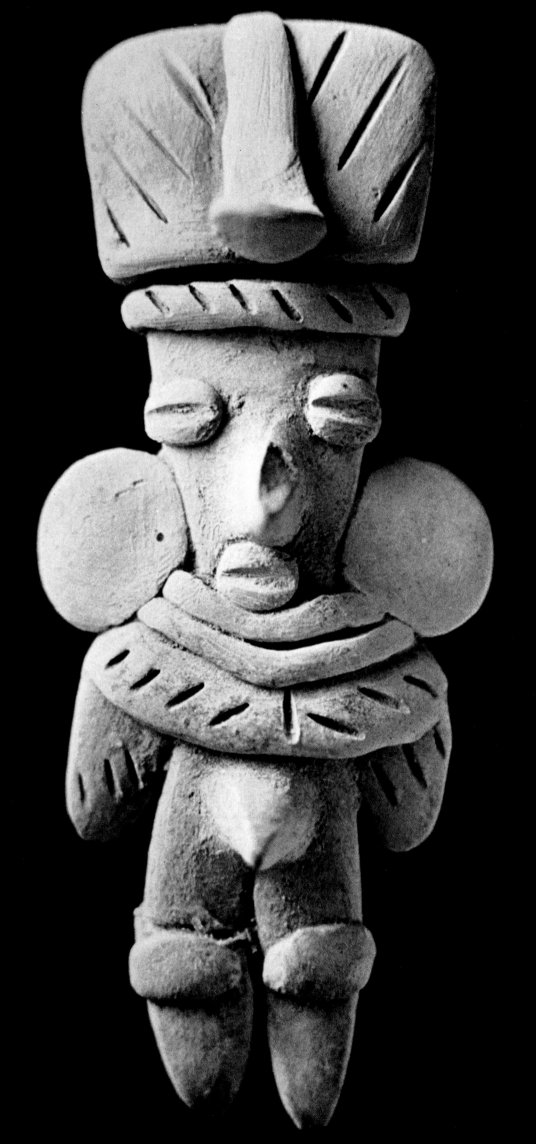

Veracruz *(Pre-Classic & Proto-Classic)*

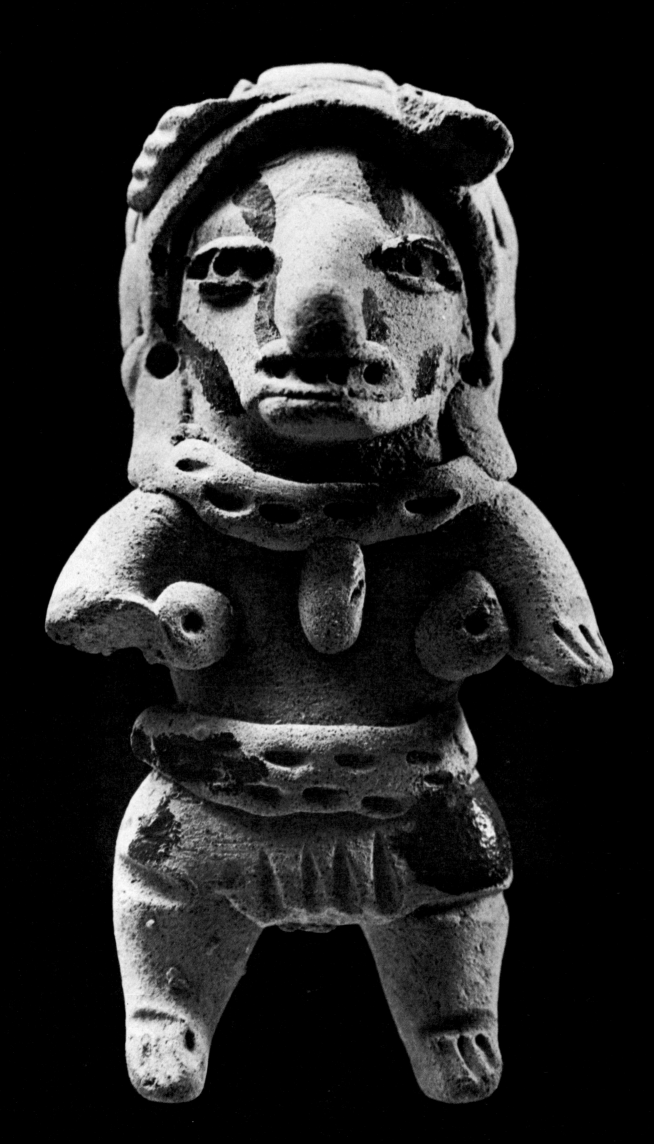

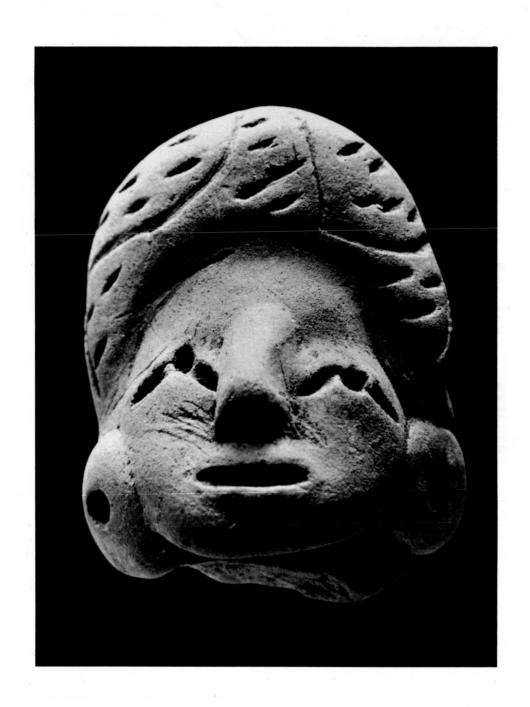

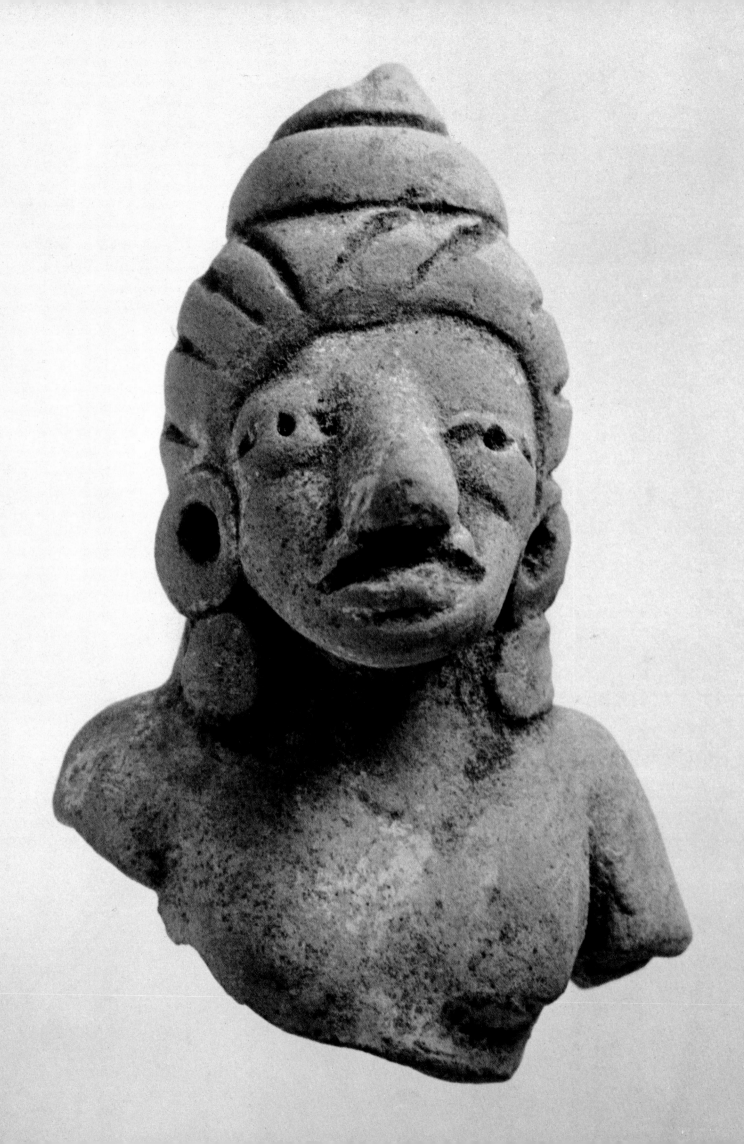

Teotihuacán

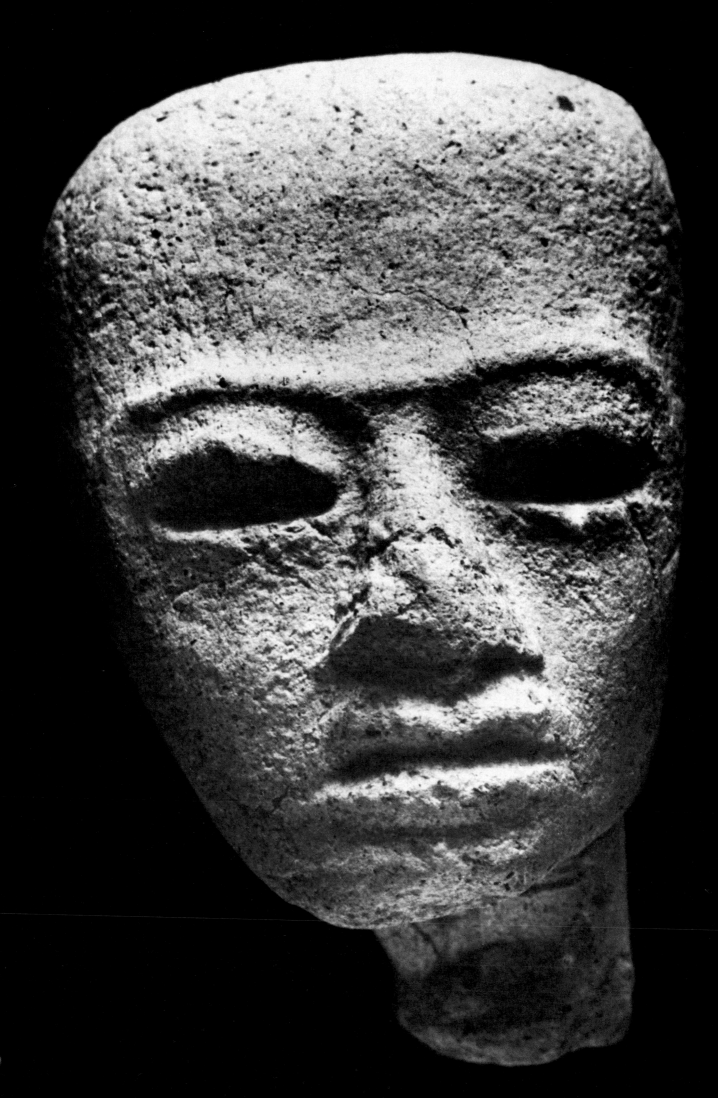

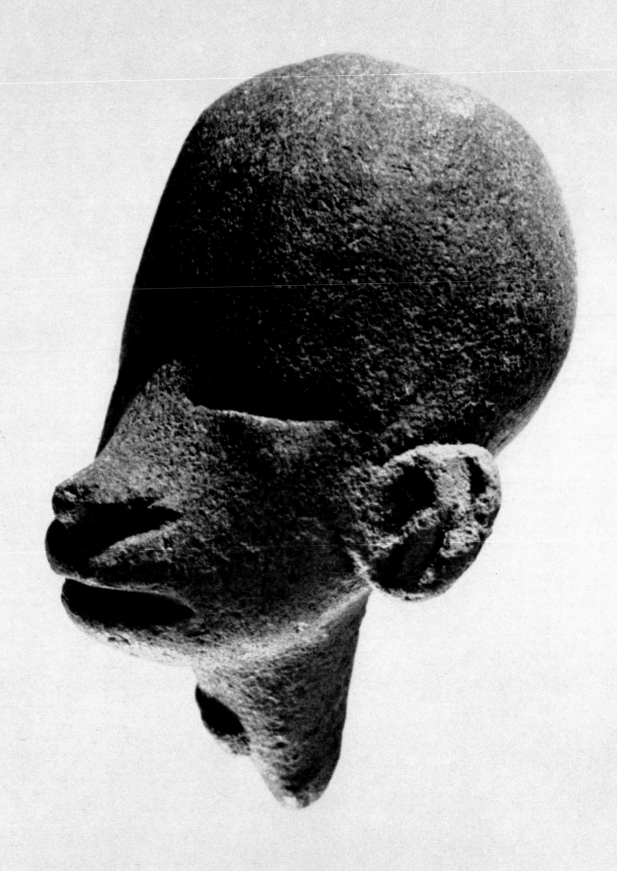

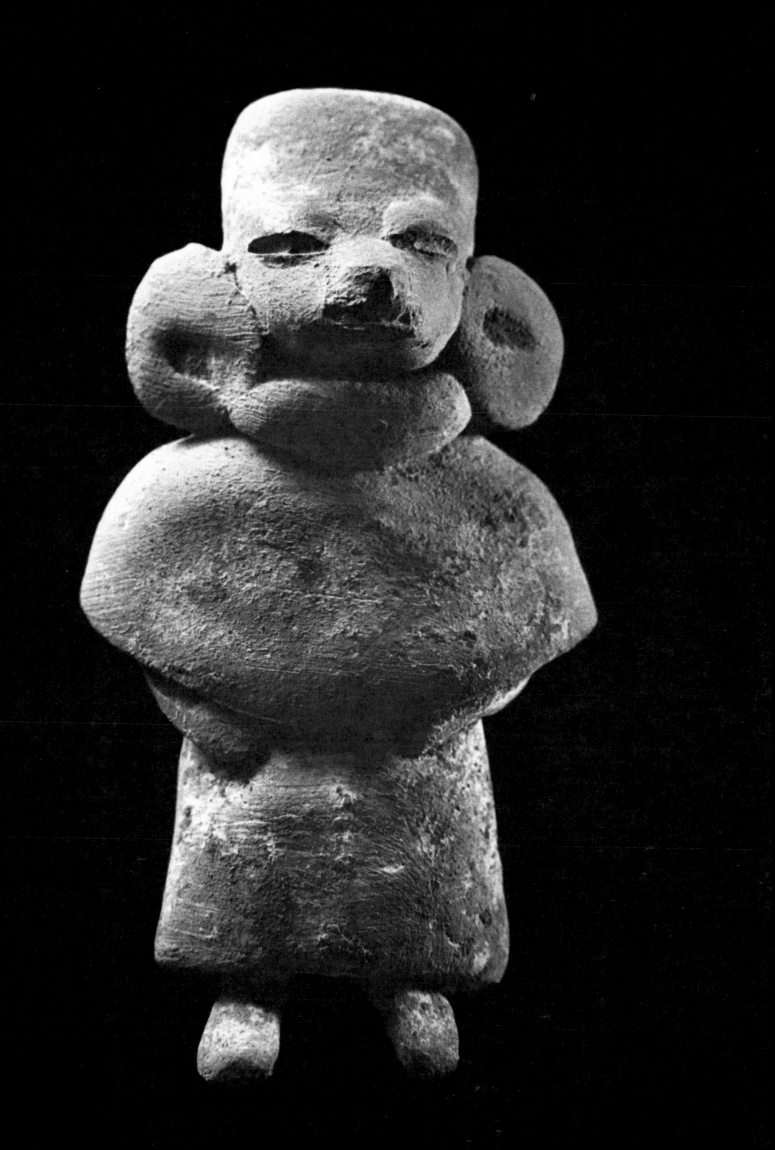

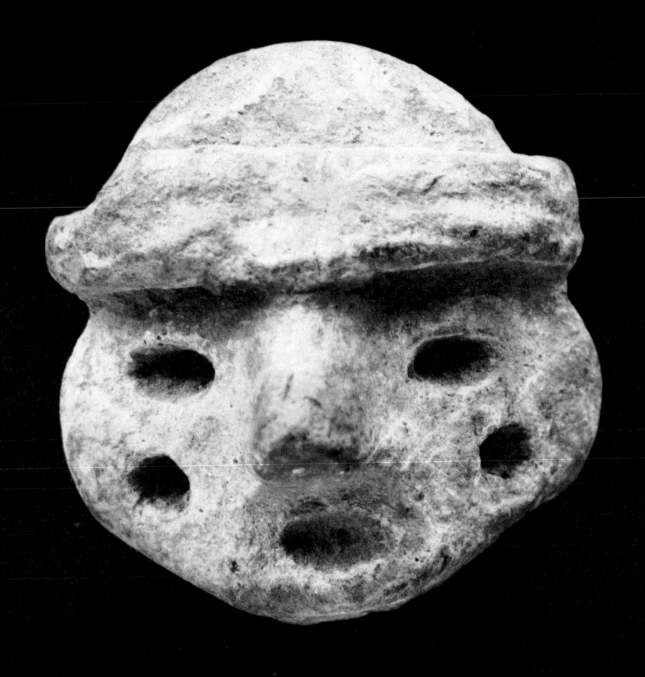

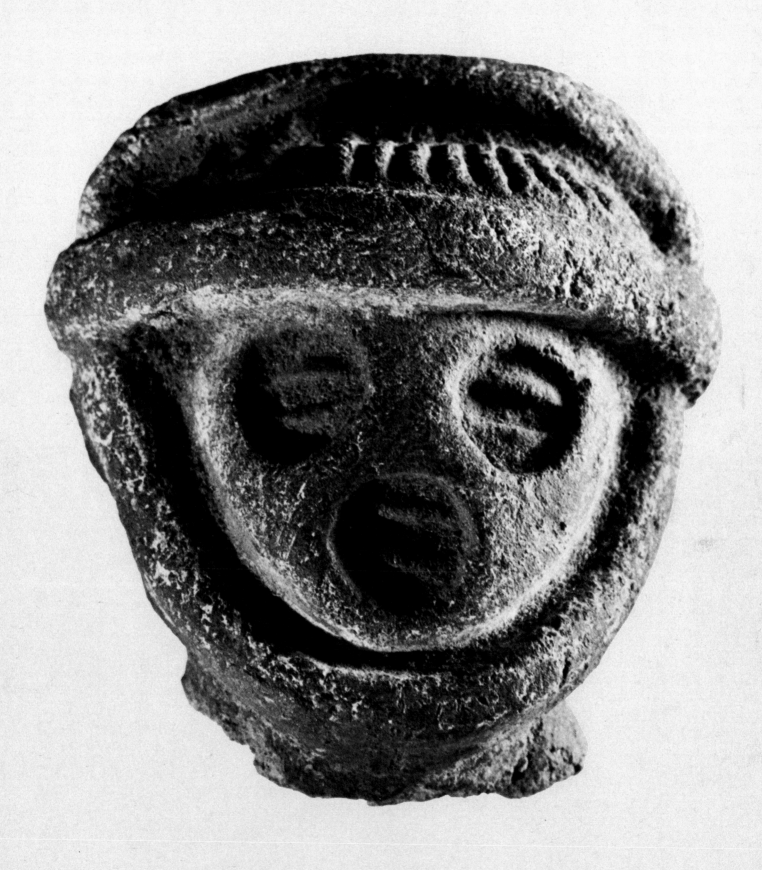

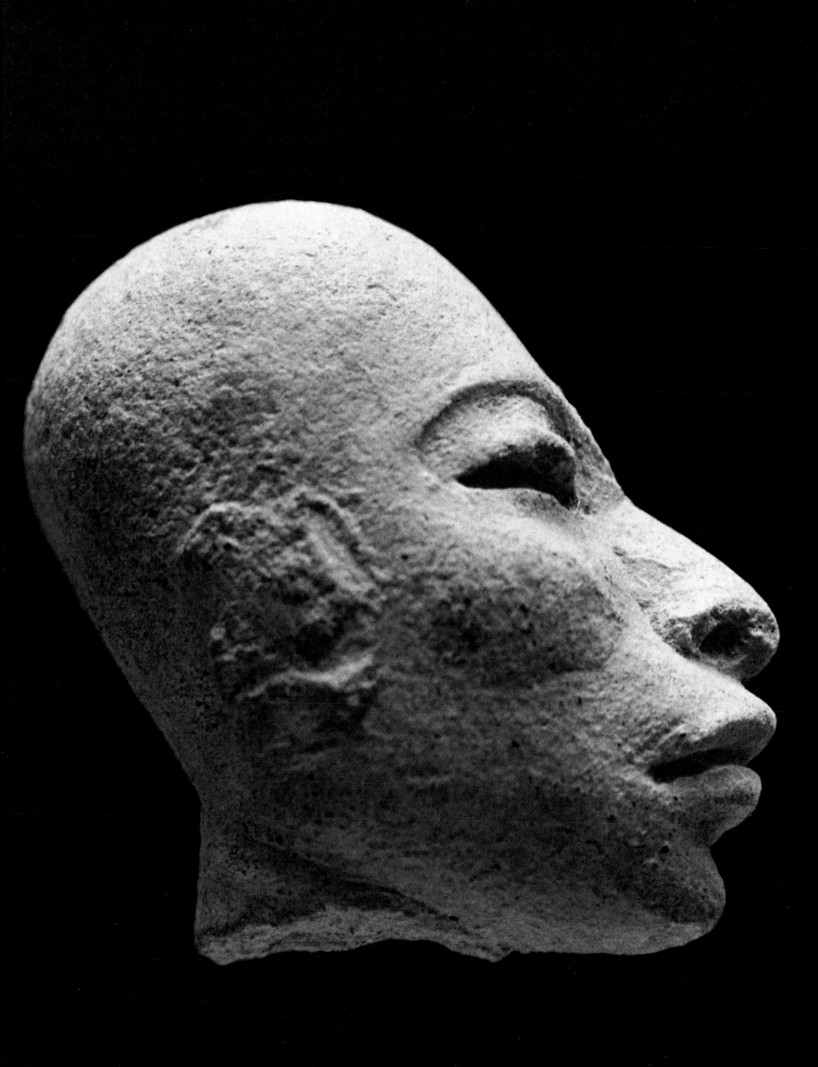

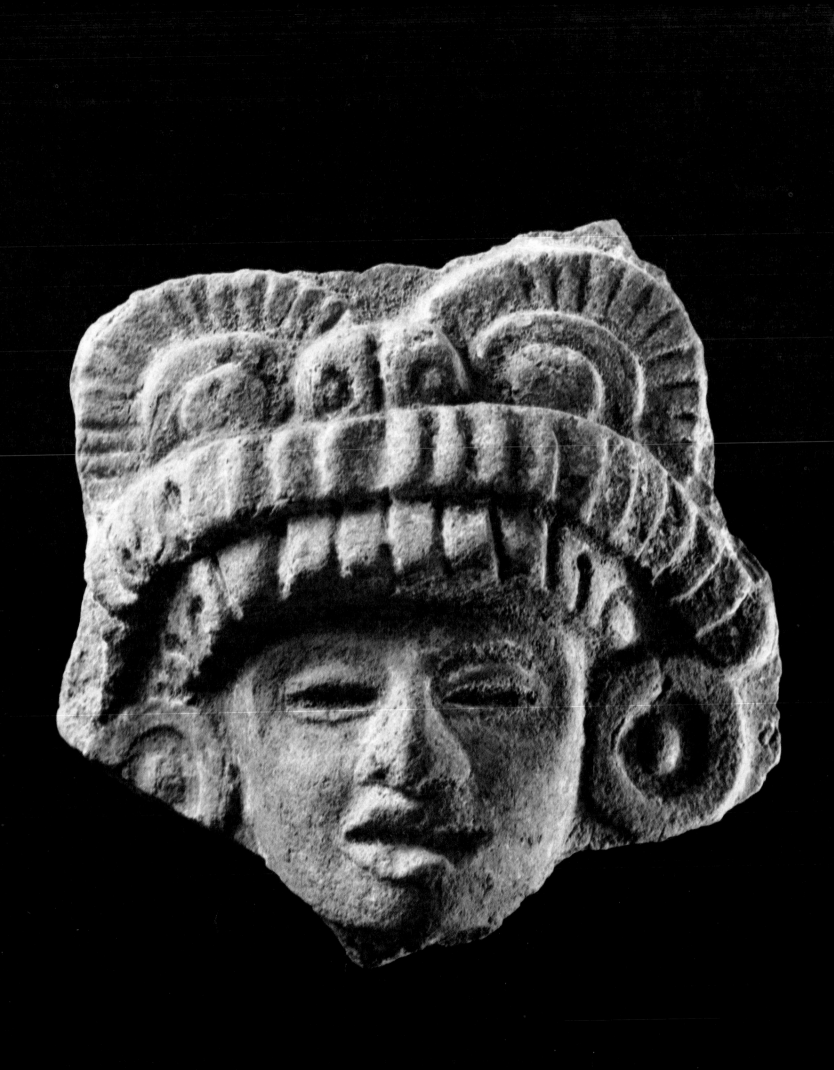

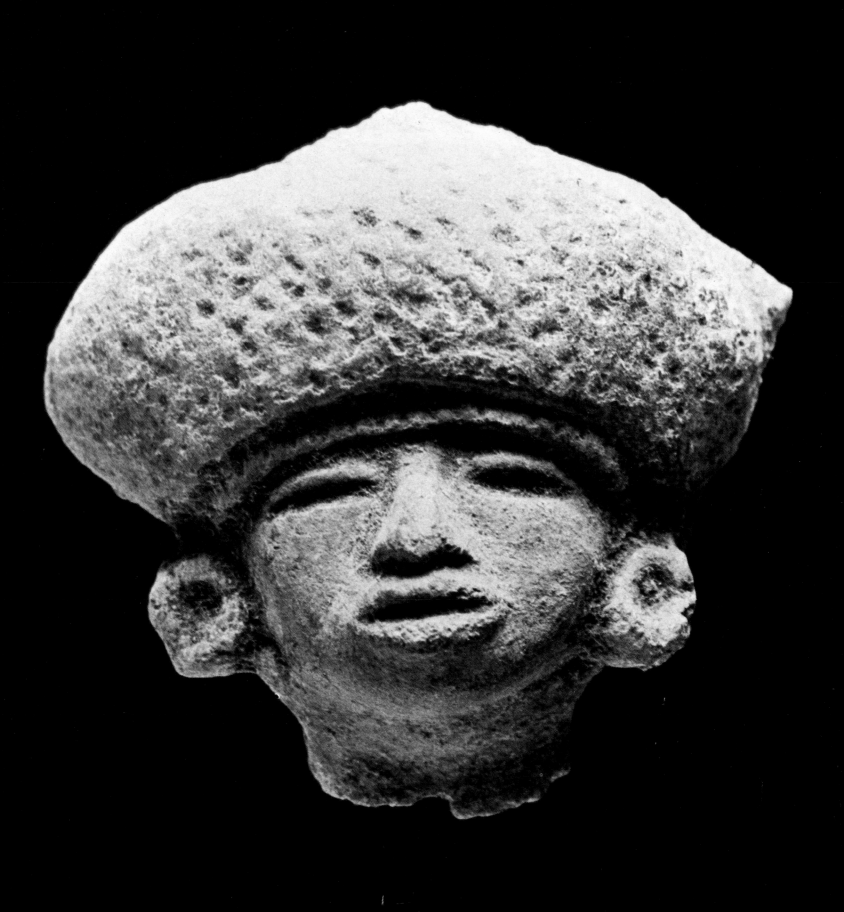

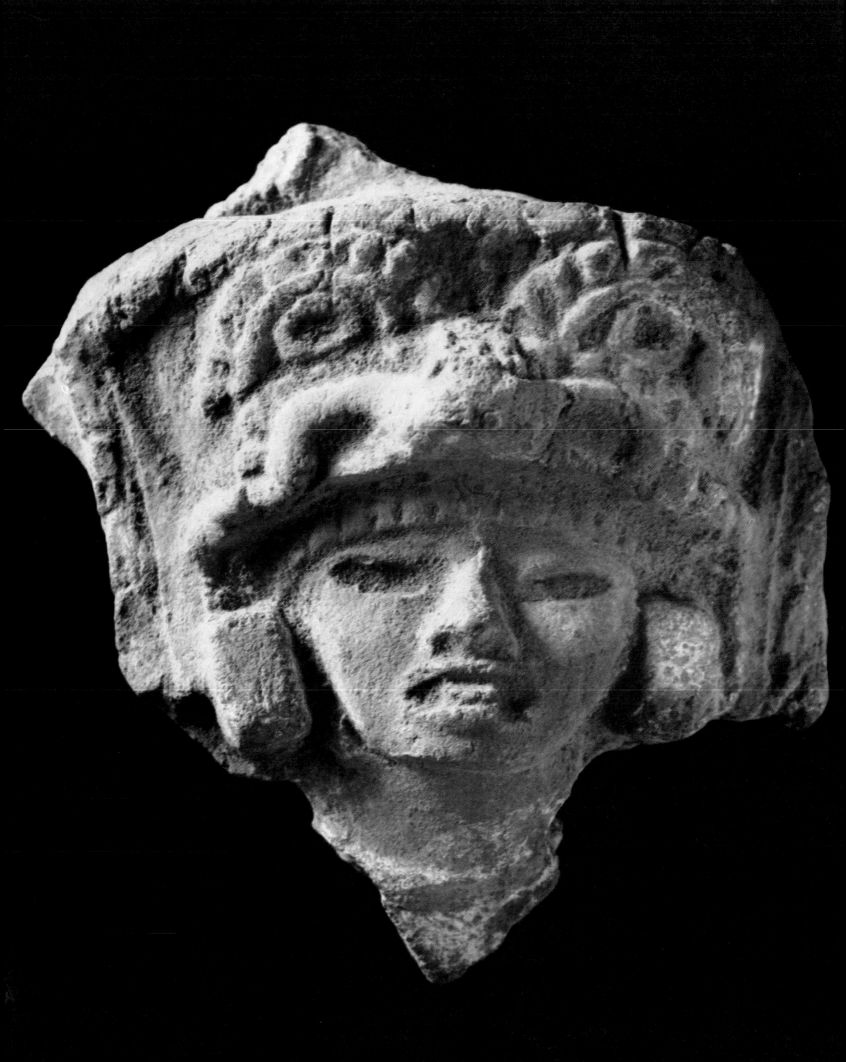

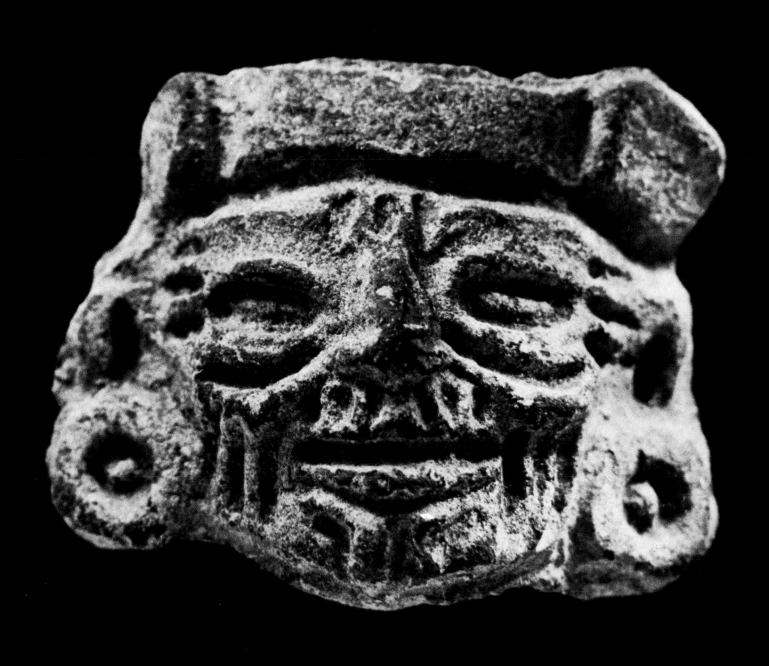

69

Late Classic Oaxaca, Monte Alban

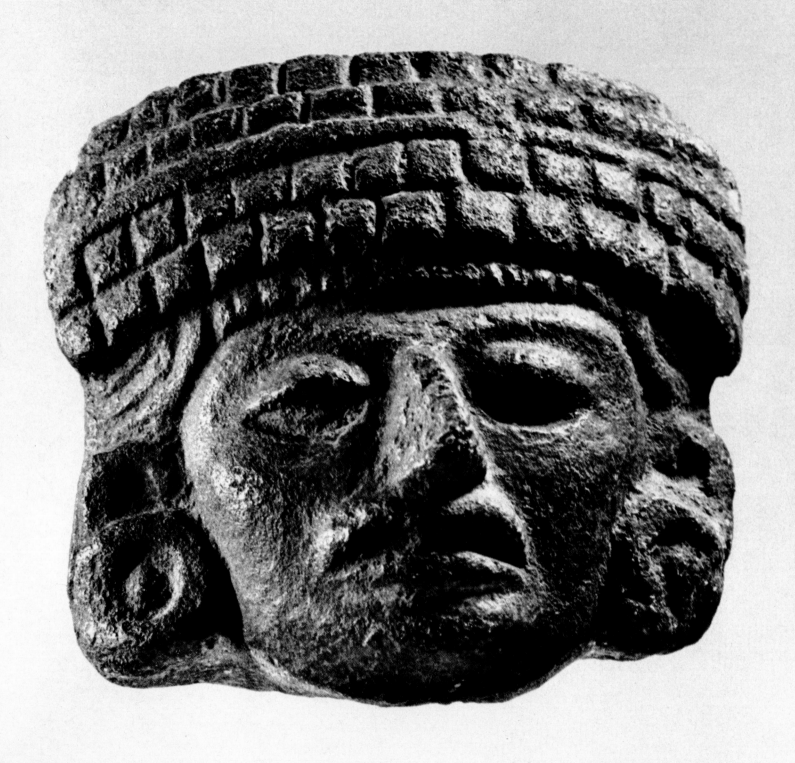

70

Maya

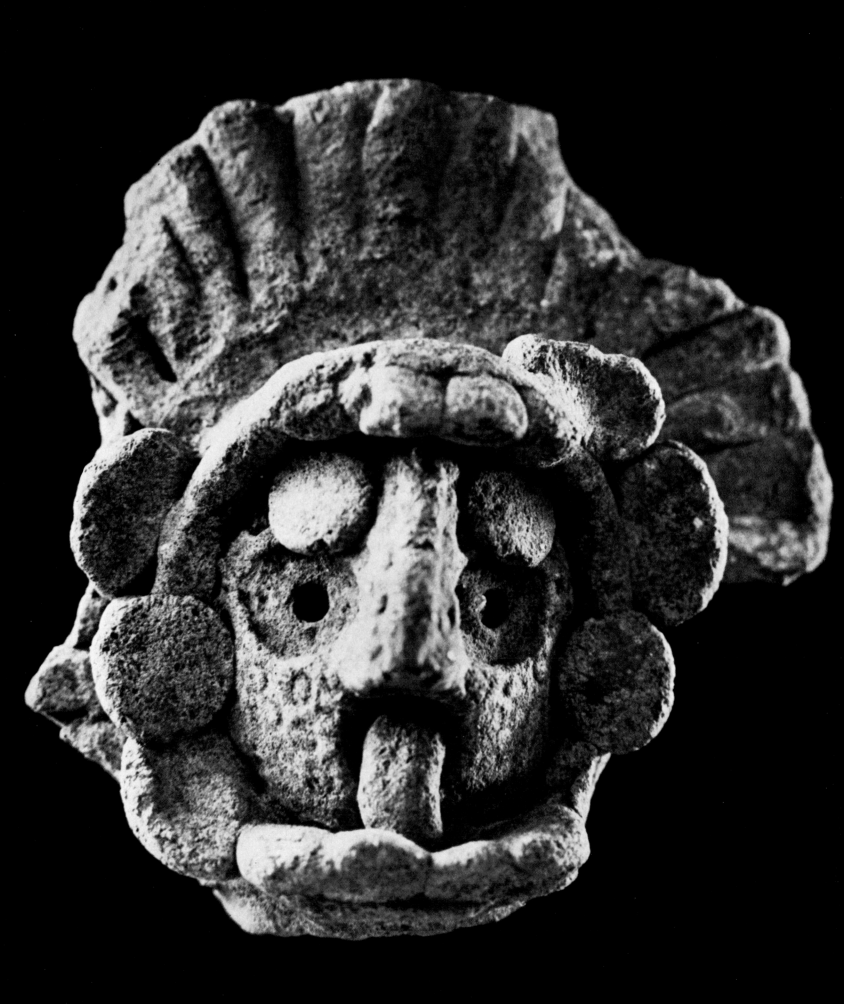

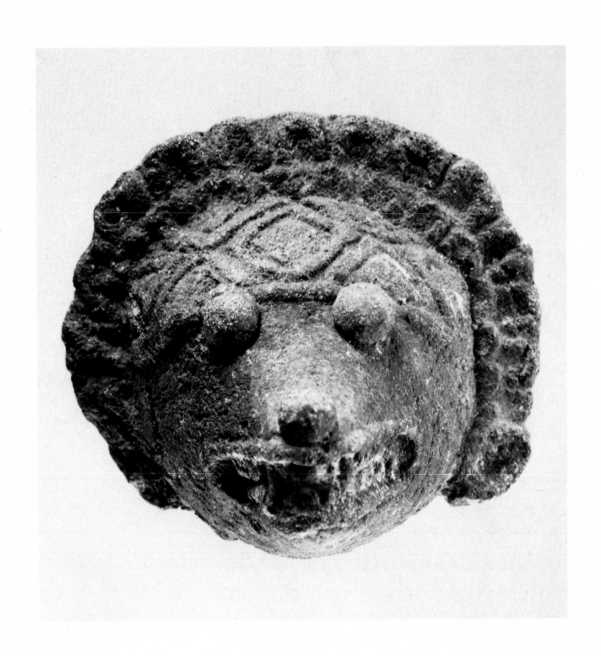

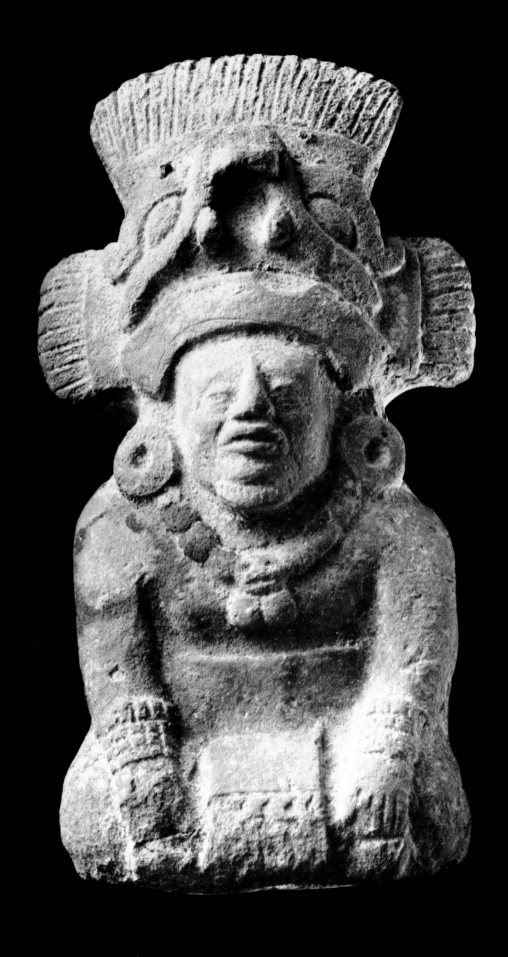

Post-Classic Mexico

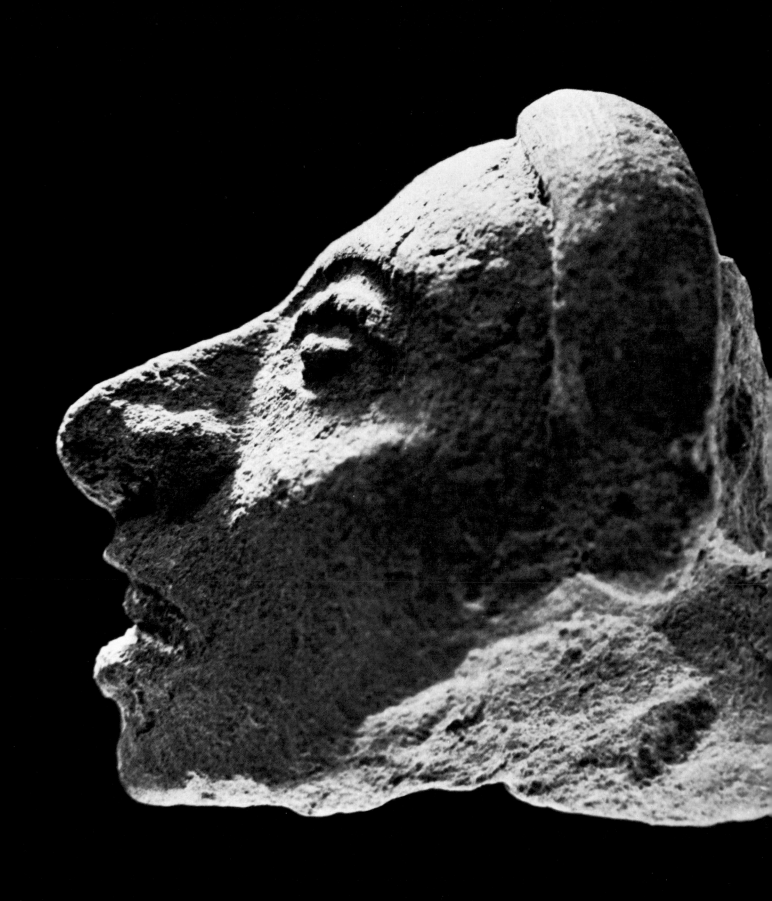

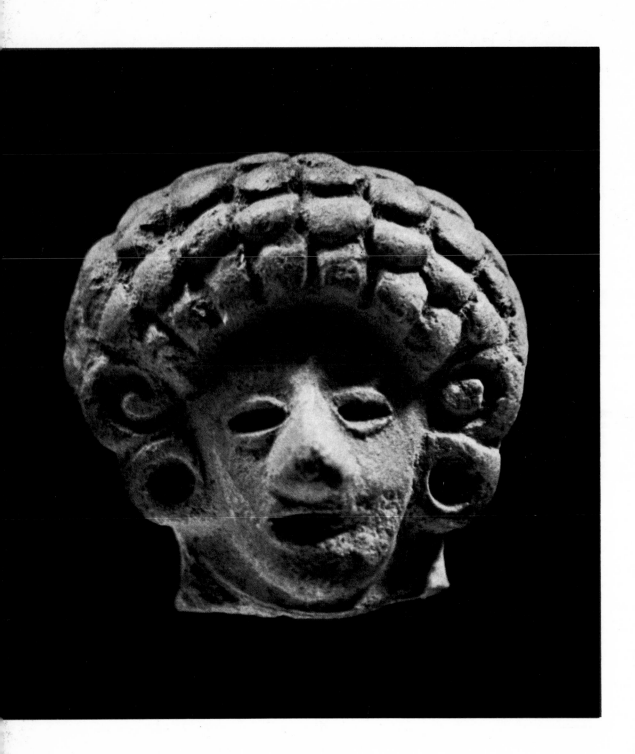

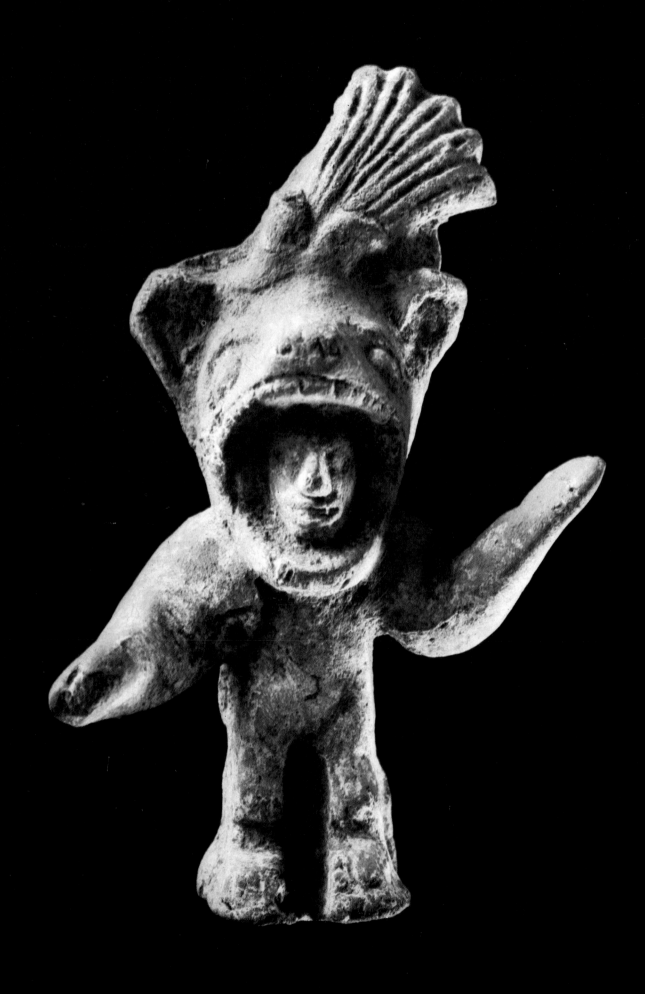

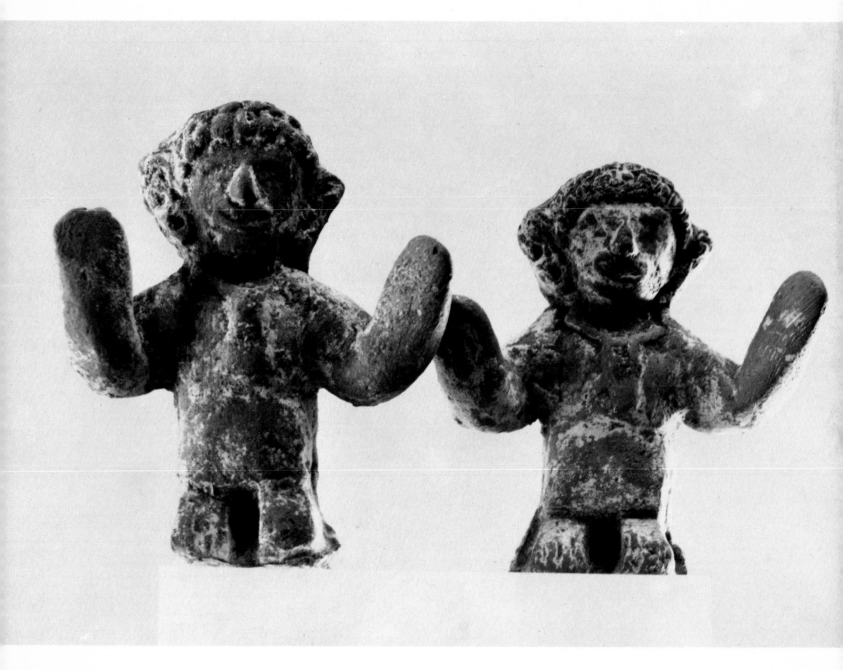

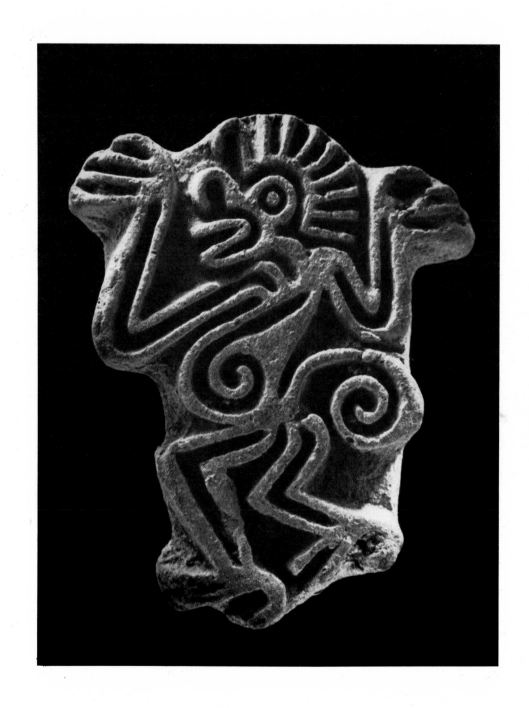

Stone Objects

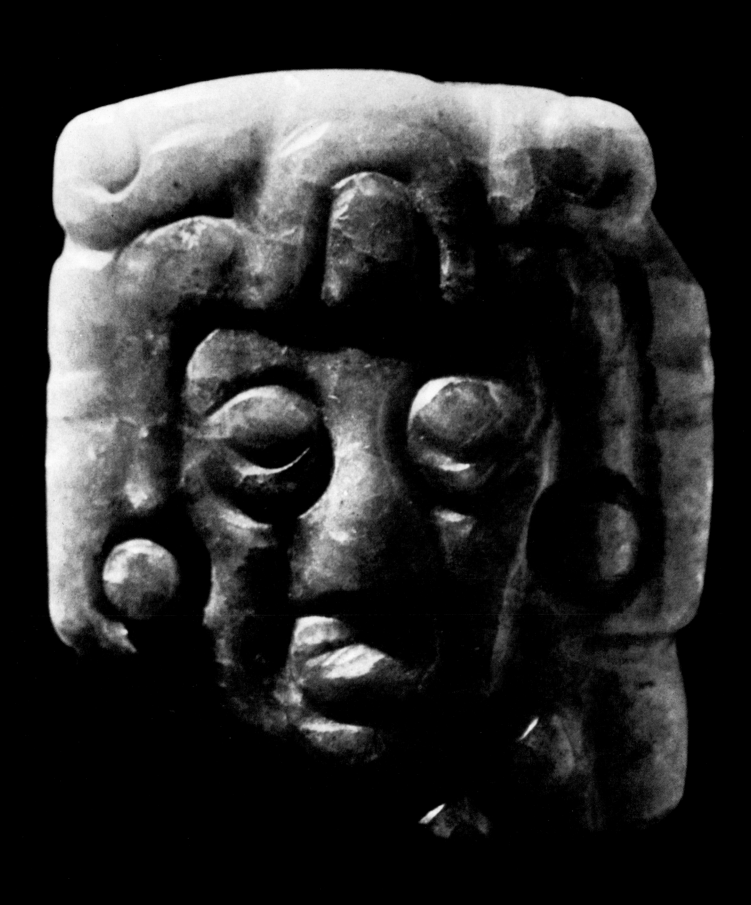

79

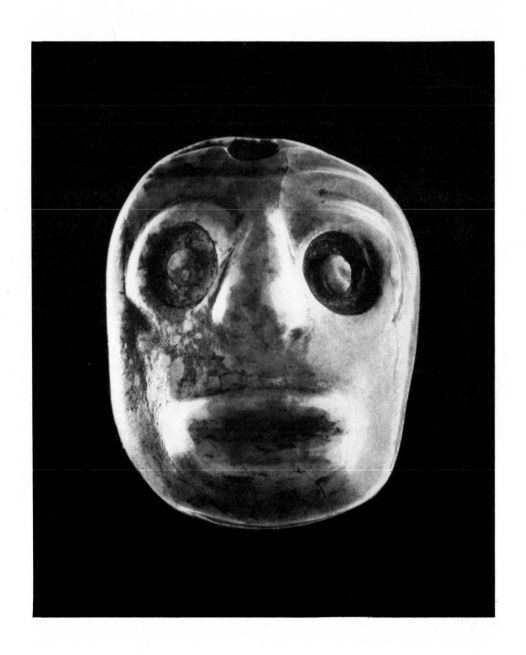

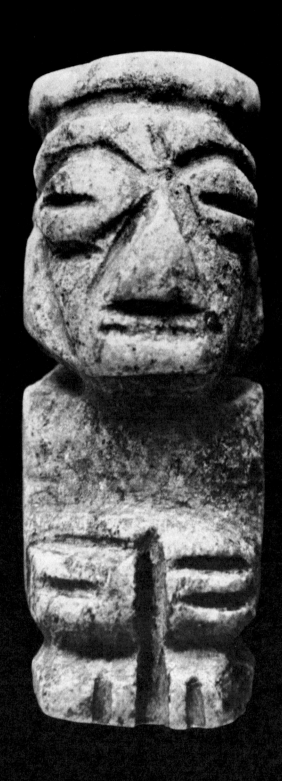

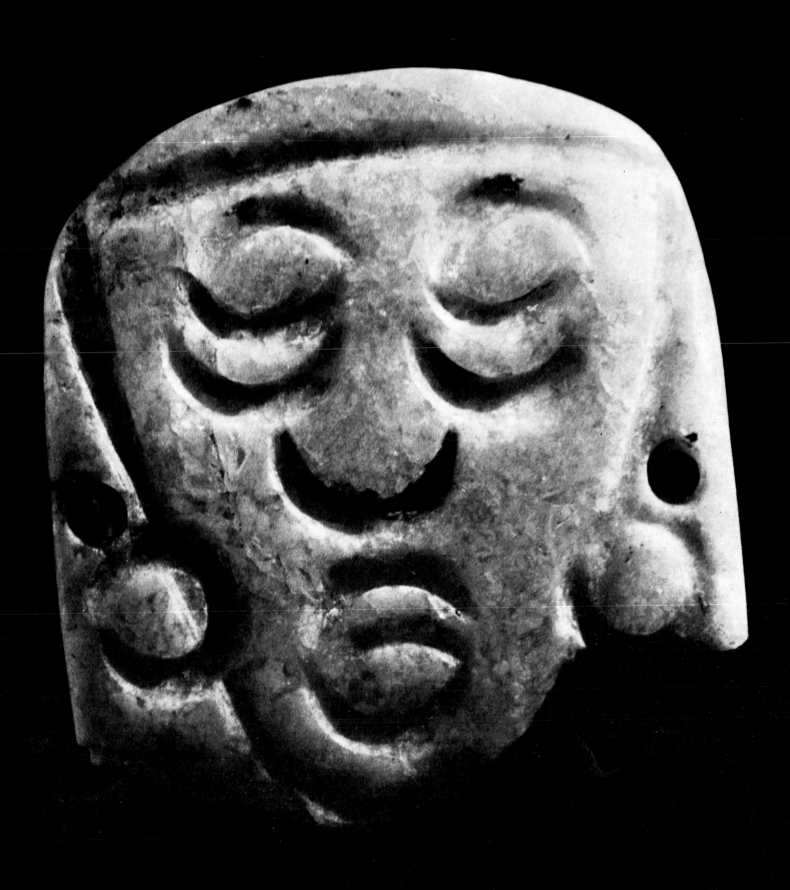

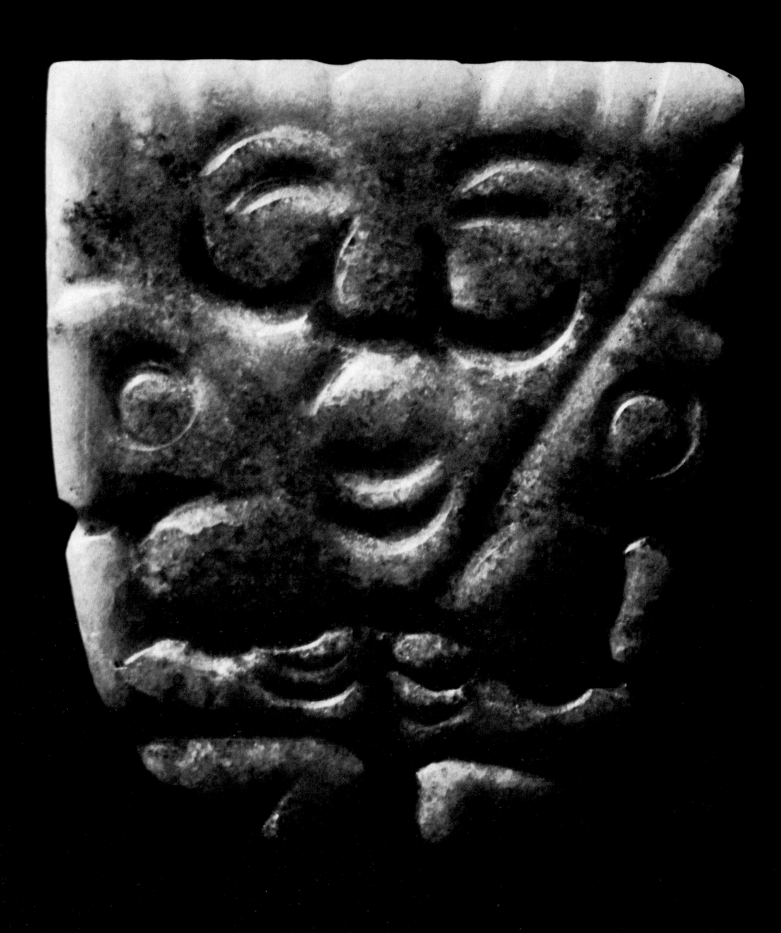

83

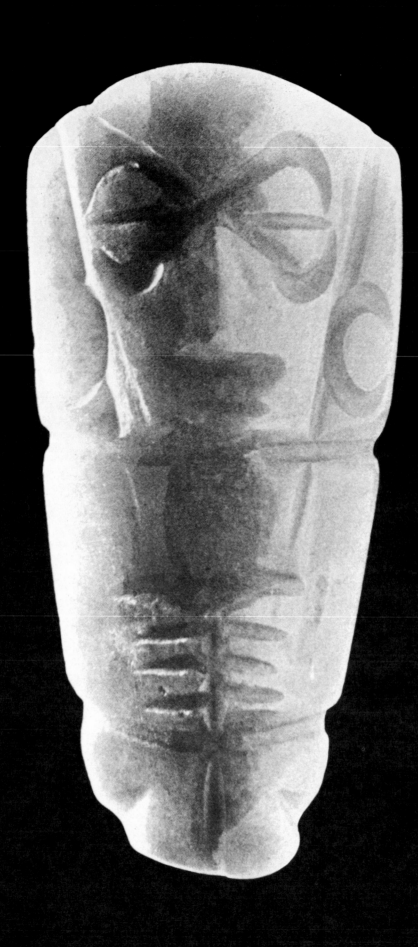

84

# Catalogue

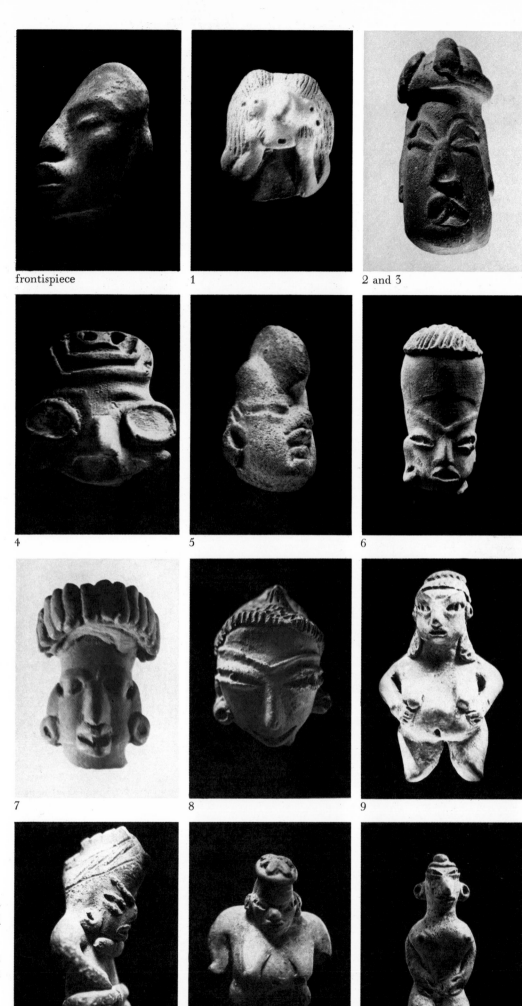

frontispiece

1

2 and 3

4

5

6

7

8

9

10

11

12

FRONTISPIECE Head of a dead person. Found in area of Cholula, Puebla. 4 cm high.

## PRE-CLASSIC VALLEY OF MEXICO

1. Type M, or Cañitas type, figurine. There is some evidence that this is the earliest kind of figurine in central Mexico, perhaps dating back to 2000 B.C. $3\frac{1}{2}$ cm high.

2. Olmec head, Type D-C$^9$, from central Mexico. While this head has the characteristic down-drawn mouth and full chin of the Olmec, its Type C eyes show it to be as late as the Middle Pre-Classic (800–300 B.C.). 6 cm high.

3. Same as 2.

4. Type K figurine, probably from Tlatilco. The goggle-like eyes are characteristic. 3 cm high. White and red pigment.

5. Olmec head, central Mexico. The "horn" protruding from the forehead is shared by the tomb figures of western Mexico. Probably Early Pre-Classic. 4 cm high.

6. Type D$^1$ figurine head, Tlatilco. $6\frac{1}{2}$ cm high.

7. Type B head from the Middle Pre-Classic, Valley of Mexico. 5 cm high. Some red pigment.

8. Type D$^4$ figurine head, Tlatilco. 5 cm high.

9. Type D$^1$ figurine of a pregnant woman, Tlatilco. 6 cm high. Remnants of white pigment.

10. Deformed person, possibly with head-horn, Tlatilco (?). 7 cm high. Some red pigment.

11. Type D$^1$ figurine of a grossly fat woman with fringed skirt. Tlatilco. $4\frac{1}{2}$ cm high.

12. Type D$^1$-D$^4$ figurine of a micro-cephalic woman with exaggerated breasts, Tlatilco. $6\frac{1}{2}$ cm high. Some red pigment.

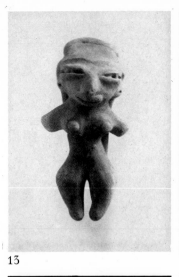

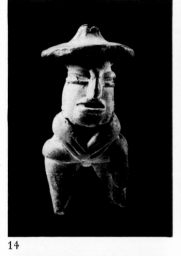

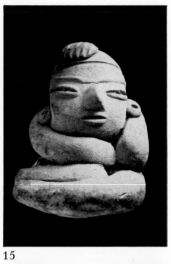

13. Hybrid figurine between D¹ and D⁴ types, Tlatilco. 5½ cm high. With red pigment.

14. Grotesque male figure, Tlatilco (?). 8 cm high. Dark gray clay.

15. Type D¹ figurine, Tlatilco. 5 cm high.

13

14

15

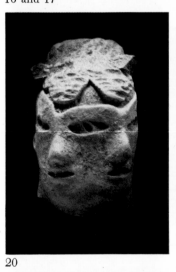

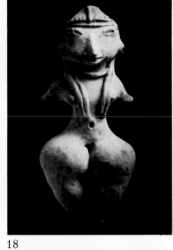

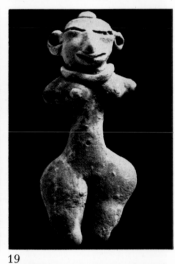

16. Type D⁴ figurine from Tlatilco. The enormously fattened thighs and delicate facial features (note that the treatment of eyes and mouth is identical) are typical. 6½ cm high.

17. Back view of 16.

18. Type D⁴ figurine with braids and pigtail, Tlatilco. 8½ cm high. Some red pigment.

19. Type D⁴ female, Tlatilco. 8 cm high. With red pigment.

16 and 17

18

19

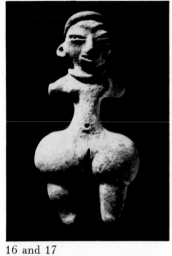

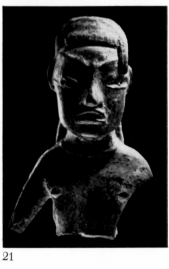

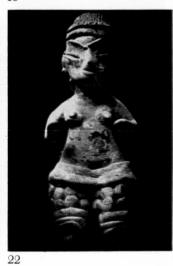

20. Type D¹ multifeatured head, Tlatilco. 3½ cm high.

21. Type D¹ figurine head and torso, Tlatilco. 5½ cm high. With red pigment.

22. Type D⁴ female dancer, Tlatilco. Rattles, perhaps cocoons filled with pebbles, are affixed to her legs. 10½ cm high. Traces of red and white pigment.

20

21

22

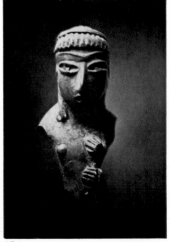

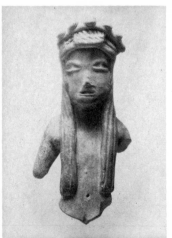

23. Type D¹ figurine, Tlatilco. 6 cm high.

24. Type D¹ figurine of a young woman with long tresses, Tlatilco. 7½ cm high.

23

24

## CHUPÍCUARO

25. Fat lady, "slant-eye" type, Chupícuaro. 8½ cm high. Traces of red and white pigment.

26. Detail of 25.

27. Person strapped to a couch, Chupícuaro. He is being suckled by a standing woman whose head is missing. 6 cm high.

28. Seated figure, Chupícuaro (?). 6 cm high. Red and white pigment.

29. Polychrome figure, Chupícuaro. The body is painted with the stepped motif also found on pottery from this site. 5½ cm high. Colors are red, white, and black.

30. Figurine head, Chupícuaro. 4½ cm high.

31. Standing figure, Type E², Chupícuaro. 7½ cm high.

32. Ballplayer, carrying ball, "choker" type, Chupícuaro. 9½ cm high. Lightly glazed.

33. Standing female, Chupícuaro. 12½ cm high. Light beige clay.

34. Woman holding breasts, "choker" type, Chupícuaro. 8½ cm high. Lightly glazed and some traces of red pigment.

35. Male ballplayer, with arm- and leg-guards, "slant-eye" type, Chupícuaro. 7 cm high. Some red and white pigment.

36. Male ballplayer with wrist guard, "slant-eye" type, Chupícuaro. 7 cm high. Some red and white pigment.

37. Seated figure, Chupícuaro (?). 6½ cm high. With red pigment.

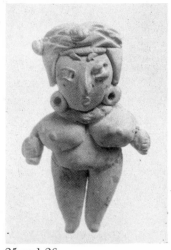
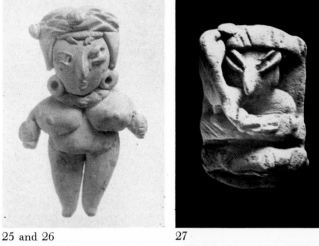
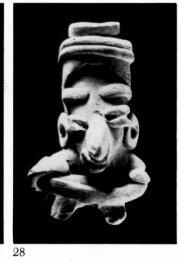

25 and 26

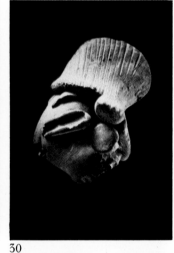

27

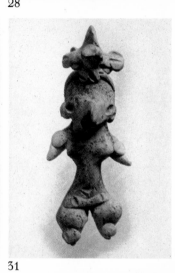

28

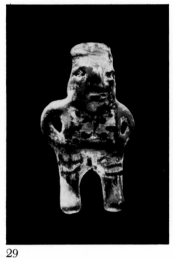

29

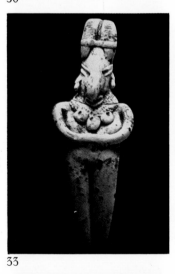

30

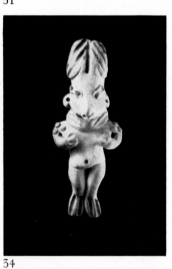

31

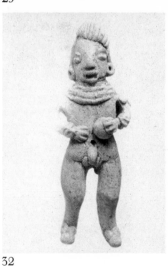

32

33

34

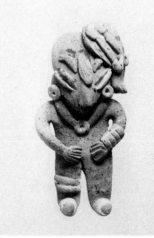

35

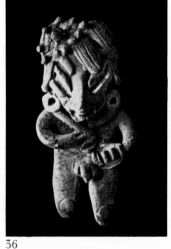

36

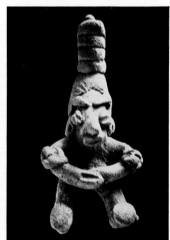

37

38. Seated figure, Chupícuaro (?). 5 cm high. With red pigment.

39. Mother and child, Chupícuaro. 5½ cm high. Some red pigment.

40. Woman with child, "slant-eye" type, Chupícuaro. 5½ cm high. Some red pigment.

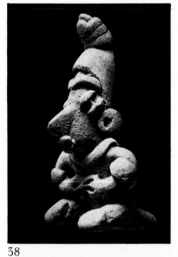 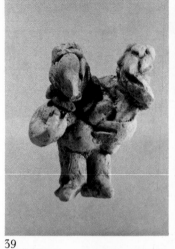 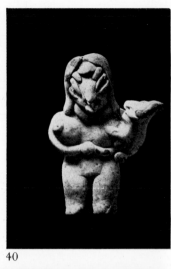

38 39 40

41. Two figures, Chupícuaro. Left, woman carrying child on back; right, male (probably a ballplayer) with mirror-like ornament around neck. Left figure, 4 cm high; right, 5 cm high. With some red pigment.

42. Two women, Chupícuaro. Both 4 cm high. With red and white pigment.

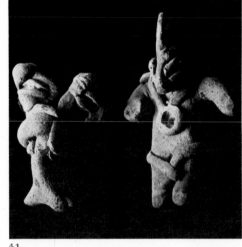 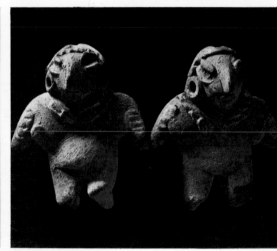

41 42

MICHOACÁN AND
GUERRERO
(*Pre-Classic*)

43. Profile of figurine head, Michoacán. The extremely flattened head caricatures artificial deformation of the skull. 3 cm high.

44. Male figure, Michoacán or Guerrero, Guanajuato. 9 cm high.

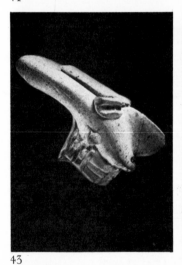 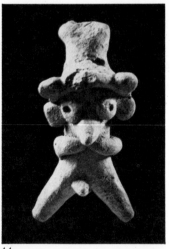

43 44

45. Two seated male figures, Michoacán or Guanajuato, in the same style as 44. 4 cm high.

46. Standing female, from border area of Michoacán and Nayarit. The multiple rings through the ears relate this and 50 to the Late Pre-Classic tomb figures of Nayarit. 8 cm high. Dark clay.

47. Same figure as 46, side view.

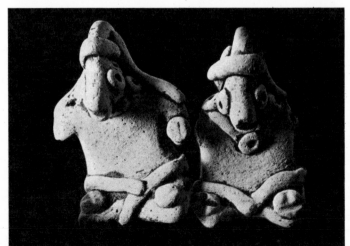 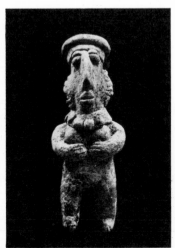

45 46 and 47

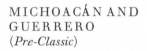

48. Seated female, Type G², Michoacán or Chupícuaro.  5½ cm high.

49. Man lying on a bed, Michoacán or Guanajuato. Such reclining figurines are common in Pre-Classic cultures of central-west and western Mexico. Bed, 3½ cm high; separate figure, 2 cm high.

50. Female figure, Michoacán-Nayarit border area, Chinesco (?).  10 cm high.

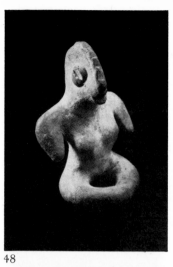 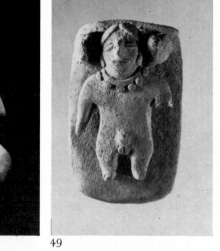 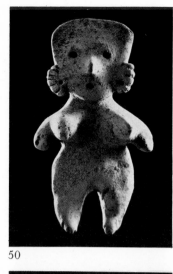
48                          49                          50

51. Female figurine head, Queréndaro, Michoacán.  5 cm high.

52. Figurine head, coastal Guerrero.  5½ cm high.

53. Female head, coastal Guerrero.  6½ cm high.

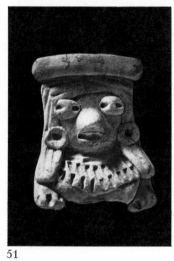 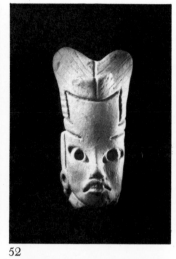 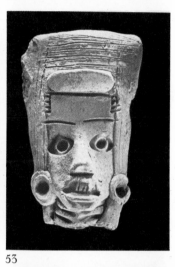
51                          52                          53

54. Standing female figure, Michoacán in the same style as 43.  10 cm high.

55. Female figure, Michoacán. This and 56 belong to a style that brings abstraction of the human body to an astonishing degree of perfection.  8½ cm high. Faint traces of red pigment.

56. Male figure, Michoacán.  9 cm high. Faint traces of red pigment.

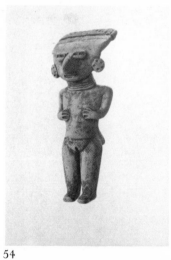 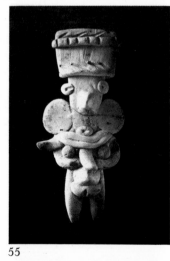 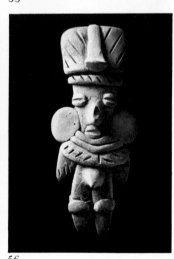
54                          55                          56

VERACRUZ (*Pre-Classic and Proto-Classic*)

57. Standing woman, early Remojadas, central Veracruz. The face and skirt are decorated with bitumen.  9 cm high.

58. Figurine head, Pánuco B type (Pánuco III culture), northern Veracruz.  5 cm high.

59. Female figurine, Pánuco B type, northern Veracruz.  7½ cm high.

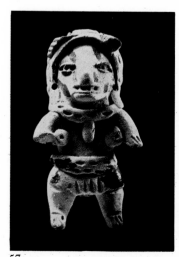 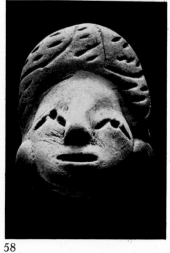 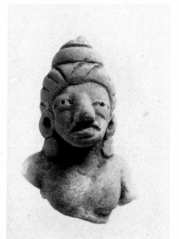
57                          58                          59

# TEOTIHUACÁN

60. Miniature portrait head broken from the body of a dancing figure, Teotihuacán III, Early Classic (A.D. 200–600). 3 cm high.

61. Figurine head, Teotihuacán II culture, Proto-Classic (A.D. 100–200). At this time, the figurine mold had not yet appeared. 2½ cm. high.

62. Standing woman, wearing *quexquémitl* (poncho) and *huipil* (skirt), Teotihuacán II. 8 cm high. Some white pigment.

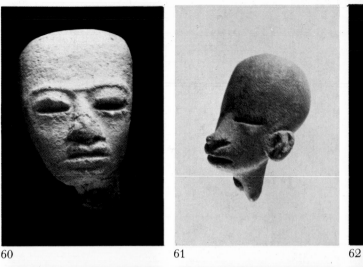

60    61    62

63. Head of Xipe, God of Spring, Teotihuacán III. 2½ cm high. Moldmade.

64. Head of Xipe, Teotihuacán III. The priest impersonating the god wears the skin of a flayed captive. 4½ cm high. Moldmade. Some traces of white pigment.

65. Miniature portrait head broken from the body of a dancing figure, Teotihuacán III. 2½ cm high.

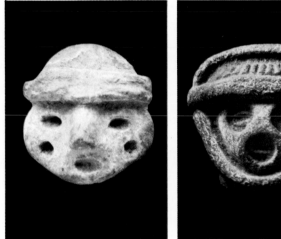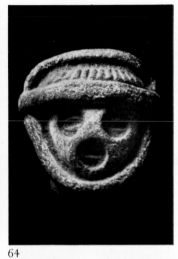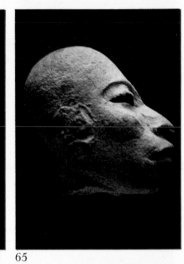

63    64    65

66. Head of man wearing animal headdress, Teotihuacán III. 4½ cm high. Moldmade. Traces of white and red pigment in headdress.

67. Figurine head, Teotihuacán III. 5 cm high. Moldmade. Red pigment on face, white on headdress.

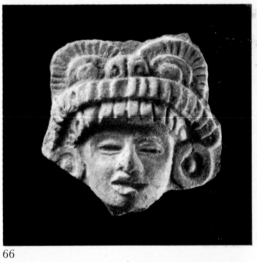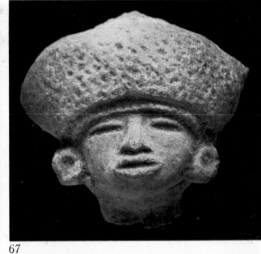

66    67

68. Figurine head, Teotihuacán III. 7 cm high. Moldmade. Some red and white pigment.

69. Head of Old Fire God, Teotihuacán III(?). 4 cm high. Moldmade. Dark clay.

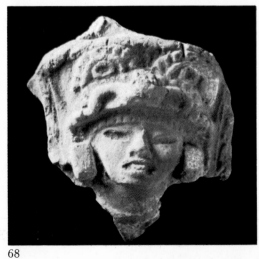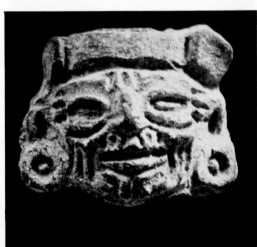

68    69

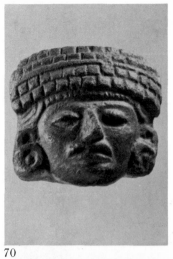

70

## LATE CLASSIC OAXACA, MONTE ALBAN

70. Monte Alban III B. Figurine head. 5¼ cm high. Moldmade.

## MAYA

71. Figure, Late Classic Maya (A.D. 600–900), Jaina. 8 cm high.

72. Animal head. 5 cm high. Moldmade. Traces of white pigment.

73. Kneeling man, Late Classic, Jaina. The front face of this figure is moldmade. 9 cm high. Traces of white pigment.

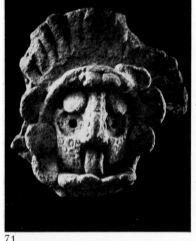

71

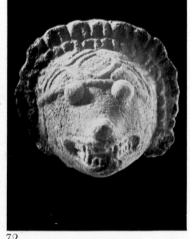

72

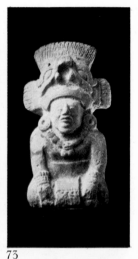

73

## POST-CLASSIC MEXICO

74. Profile head, Aztec. 3½ cm high.

75. Head. 2 cm high. Some white pigment.

76. Figure of a warrior in costume of plumed jaguar, Aztec. 5 cm. high. Moldmade. Traces of white pigment.

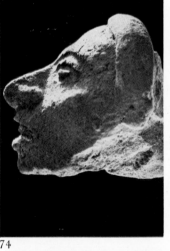

74

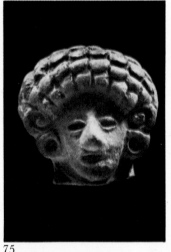

75

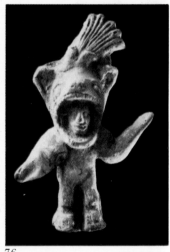

76

77. Pair of identical figures, Aztec. Left, 5 cm high; right, 4½ cm high. Moldmade.

78. Flat stamp of a running monkey, possibly Aztec. 5 cm high.

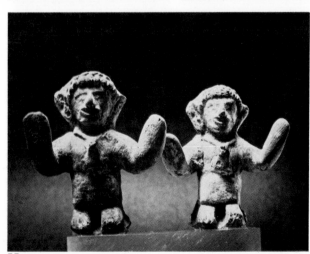

77

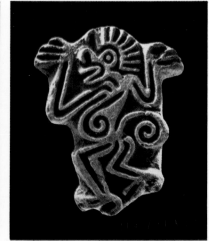

78

## STONE OBJECTS

79. Pendant, Late Classic Oaxaca. 3 cm high. Jadeite.

80. Pendant, culture unknown. 3½ cm high. Jadeite.

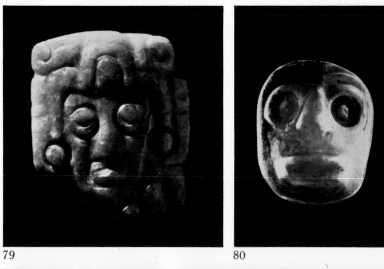

79

80

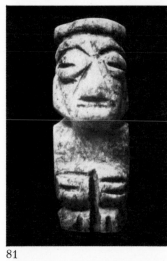

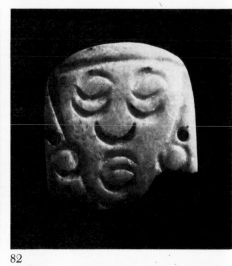

81

82

81. Figure, probably Post-Classic (A.D. 900–1521), Oaxaca. 3½ cm high. Serpentine.

82. Pendant. Late Classic, Oaxaca. 2½ cm high. Jadeite.

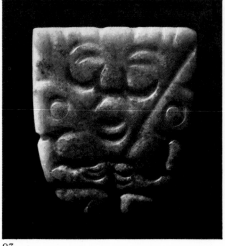

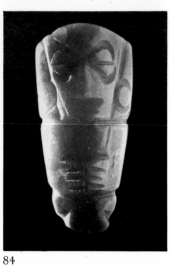

83

84

83. Pendant, Late Classic, Oaxaca. 2½ cm high. Jadeite.

84. Figure, probably Post-Classic, Oaxaca. 4 cm high. Jadeite.